"A healthy read that wi
creativity. *Kill Your Art*
individual or churches
years of tested experie
insight and practical in

your art be reborn into producing eternal and tangible fruit,
read on..."

> - Dr. Mark Schwarzbauer PhD, Pastor of Family Worship
> Center and author of *100 Days Through Matthew, Mark
> and Luke.*

"Philip's passion for street storytelling is intriguing, lively
and otherworldly. His desire to see Jesus made famous—in
places and to people who likely will never hear the gospel
story as he is gifted to tell it—is refreshing of the tallest
order. This book is a powerful resource to any artistically-
wired follower of Jesus seeking to engage culture way
outside the four walls of church. Any artist willing to kill
their art is ultimately the hero for recognizing gift is never
higher than giver. God doesn't need more gifted creatives
to show off skill, He's seeking a generation willing to
surrender everything (including the very gift they've been
given). Philip qualifies as dangerous soul with a sharp
message."

> - Chad Johnson, Founder of Come&Live! and former A&R
> of Tooth and Nail Records.

"Philip Shorey has poured out his soul into this debut
book! Because Philip is an artist in every sense of the word
his ministry style is creative and out-of-the box. I am so
grateful that Philip took the time to skillfully guide and
prepare others with his stories of Christ-like pursuit and
trial and error shepherding. The lessons Philip has learned
are truly stirring and will leave all who read them (left and
right brained alike) inspired to use every gift at hand for the
time is NOW!"

> - Leanor Inez Ortega Till, Saxophonist of *Five Iron Frenzy*
> and urban shepherdess to a wandering flock of believers
> and seekers.

"Philip Shorey is one of the most authentic and radical
preachers of the gospel that I know. Read his book and be
challenged!"

> - David Pierce, Founder of Steiger International and the
> band *No Longer Music.*

KILL YOUR ART

A Street Performer's
Guide to Being
a Messenger of
Jesus Christ

Philip Shorey

 steiger press

"In fact every command of Jesus is a call to die, with all our affections and lusts."

- Dietrich Bonhoeffer, *The Cost of Discipleship.*

Kill Your Art

Published by Steiger Press
PO Box 236
Wheaton, IL 60187-0236

www.steiger.org
intoffice@steiger.org

ISBN 978-0-9978649-1-5

Acknowledgments

This book would not have been possible without the love and support of my wife and best friend Sari. Also, a huge thank you to all our supporters and the many people who have prayed and believed in this crazy mission we have been on over the years. Thank you to Dave Wilson, Paul Shively, Andrew Dirks, Mark Johnson, Chad Johnson, Luke Greenwood, Celinda Olive, Charles de Bueger, Wes and Nica Halula, Mark Anderson (Q), Jake "The Snake" Chaya, Dustin Kelm, Sandro Baggio, and David Pierce for your critical thinking, encouragement, and help with my grammar.

Collage Artist: Sally Grayson
Design Director: Felipe Rocha
Editor: Molly Paulson
Writing Consultant: Leanor Ortega-Till

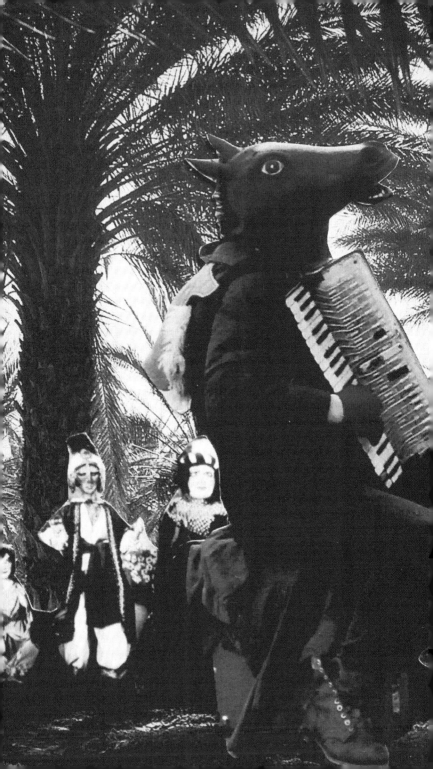

KILL YOUR ART

"Truly, truly, I say to you, unless a grain of wheat falls into the earth and dies, it remains alone; but if it dies, it bears much fruit."

John 12:24 ESV

Contents

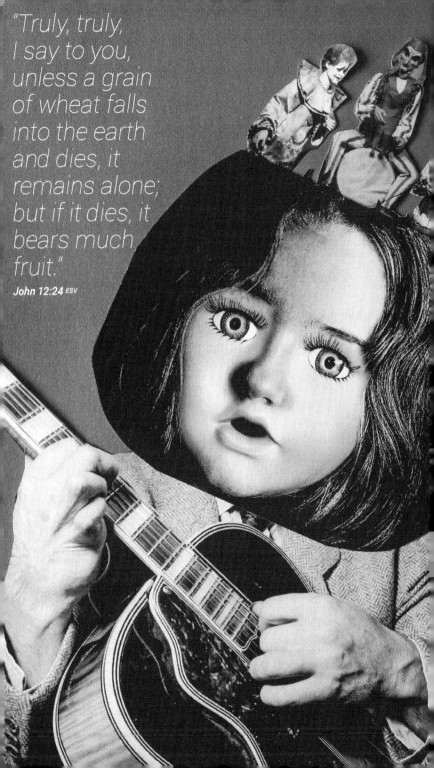

"Truly, truly,
I say to you,
unless a grain
of wheat falls
into the earth
and dies, it
remains alone;
but if it dies, it
bears much
fruit."

John 12:24 ESV

KILL YOUR ART

MOTIVATION

There have been a number of moments in my life when I have hit a wall and come to terms with the fact that if my walk with God was going to continue to grow, it was time to let go of new areas that were coming between me and God: my dreams, food preferences, career opportunities, finances, and art. It's not that those things were wrong; it's just that even though I had surrendered my life to Jesus, they still provided a place where my flesh could peek its ugly face through and make me believe that I was better off to hold onto them, instead of give them away to Jesus. That is what this book is about—killing your art by surrendering it to Jesus. Dying to yourself, picking up your cross, and following Jesus so that he can use you to bring his love to a broken world (Matthew 16:24).

Picking up your cross and dying to yourself will look different for every artist. It has been in the unexpected street corners and plazas of the world where Christ has done a beautiful work in me and my art.

Street performance, or busking, is a form of public entertainment where the artist and the audience are on the same level, oftentimes in public places, and where the artist performs for free or receives gratuities. Street theater dates back to antiquity. In ancient Biblical times, the prophet Ezekiel appears to use a form of street theater to depict strange parables. His acts included human dung, shaving his head, and using miniature models of Jerusalem to speak to the people of Israel on behalf of God (Ezekiel 4-5). In medieval times, puppet troubadours performed in the streets, markets, and jousting tournaments while depicting known Bible stories and showdowns with the devil.[1] Since the 1970's, hippies and train hoppers have emulated a romanticized "gypsy" lifestyle, performing folk music and traveling throughout the United States. Today, The Busking Project[a] is uniting buskers all over the world and helping on a political level to keep entertainment in the streets of populated business districts.

Although street performers have sometimes been privately disparaged by the establishment as "Gypsies, Tramps, and Thieves,"[2] there is an endearing romance to busking in how it cuts out the gatekeepers who control the stage and allows any artist to go straight to the people. I love the magic that occurs when the audience stumbles upon a performance and is moved by the message of an act that they would have never pursued on their own. It's the intimate connection to the audience and the devotion to the uncensored arts that makes street performance a beautiful form of entertainment. Busking however, was never something I (or most other buskers I know) ever aspired to in any serious fashion, but after I surrendered my art to Jesus, my creative passion totally transformed.

a Check out www.busk.co to learn more.

Life is too short for me to do "art for art's sake," even if art is seen by some to be a form of Christian doxology. In a similar manner, every breath we take also brings glory to our Creator, but God doesn't want us to stop there and just breathe for breath's sake. There is so much more to be done to accomplish his mission. My hunger is to do something extraordinary, and to do it with eternal worth. I have big ideas and huge dreams, and I want to be the best I can be at what I do; but the biggest dream I can ever think of is to wholeheartedly give my all to Jesus for him to use me, no matter what it looks like, or what structure it takes. That's my passion. I love art. I love music, filmmaking, sound design, theater, storytelling, fine art, photography, and composition of all sorts. But my passion is Jesus, and if I have to kill my art in the street in order for him to bear much fruit (John 12:24), then I will.

When I surrendered my art to Jesus, God changed my life. He equipped me, and gave me what I needed to do more with him than I could have ever done on my own. He revealed to me how to make a big impact with small means because of his power, not my own. He broke me and fit me back together according to his plans, not my own. He saved me from my plans!

I had grown up feeling a bit like a black sheep in my family. But after I started a traveling marionette theater called the Suitcase Sideshow, I realized I was actually the fourth generation in my family to use puppets as a tool for sharing the gospel. I wasn't a black sheep at all. I was right in line with a generational calling. This brought healing into my life in a way nothing else could. Part of this book's front cover is a photo of my great-grandfather, Aksel Rasmussen. He joined the Salvation Army as a preacher and a street performer in their marching band after receiving Jesus into his life at one of their meetings in the 1920s. In my

opinion, those old marching brass musicians were some of the earliest evangelistic street performers who killed their art, picked up their cross and followed Jesus. Later, Aksel picked up marionettes with his son and traveled all over Canada and the United States doing the same sort of thing. You can read all about our family story, spanning over 100 years of evangelistic puppet history, in the book *Travelogues of a Family Sideshow*.

Once, I was performing my marionette theater under a bridge by some train tracks in Minneapolis. We had just come off a big European tour and were pretty accustomed to our routine, but for some reason it was by far our worst technical show ever! The power broke, the puppets were tangled, and the props were all messed up. This was supposed to be a celebration of our return, not a gander at failure. I have always said, "Jesus, I will follow you to the end, even if I look like a fool," but it's never easy to say that when it's happening right then. I wasn't even able to explain the problems after the show; I just took a slight bow and sat down. "Wow, what a low point in my busking career," I thought.

After looking back on the performance, I was reminded that I am completely reliant on God. I'm no missionary hero, no miracle worker, nothing to be looked at for saving a life. It is only because of God's mercy flowing through me that anything of eternal value happens, not because of my music or art. My prayer after the show was that even though we messed it up royally, it wouldn't distract from the message. I prayed, "I am fine with not seeing the fruit of my work and even looking like a fool, but please just allow *them* to feel your power despite my imperfections." As I was sharing that with one of my helpers, a man came up to me, completely touched by the show. I had met him on the streets a few months earlier and had invited him to our show. He shared with me about his terrible day and how

he was struggling with going back to the bottle to numb his pain. But after seeing the show, he had changed his mind; he would not give in. We talked, and then I prayed with him. Afterwards, I thanked God for his mercy. My art was killed in its quality, worldly success, and pride, but God was able to awaken new life from it for his glory!

Since then, I have been touring with the Suitcase Sideshow all over the world. I have performed on street corners and in orphanages, jails, refugee camps, squats, homeless shelters, festivals, slums, and a brothel. I have translated my shows into over ten languages. I have started a street theater in Turkey where they regularly reach out to Muslims.I have seen people riot, throw rocks and beer bottles, cry, laugh, need a hug with tears of joy, and radically pray to accept Jesus into their lives after our performance. I have seen a juvenile jail transformed from being dark and gloomy to vibrant and hopeful in the years after the leaders had accepted Christ through my show. One time after a show at a Christian music festival, someone came up to me and told me that in four years going to this festival, they had never felt God's love as much as they did right then. Another time after a show, a 9-year-old boy told me he had been going to Christian school his whole life but had never wanted to follow Jesus until right then.

I have seen God shield me and do more with my unassuming show than I could have ever done on my own. All because I have been willing to surrender my art to Jesus and allow him to use it for his extraordinary plans of bringing life to a dying world. I may never become famous as a great artist. I may never compose the music for an internationally acclaimed film. But I don't need that when I'm a creative partner to the greatest Creator in the universe. Isn't real success much deeper than the momentary spotlight?

"What good is it for someone to gain the whole world, yet forfeit their soul?"

Mark 8:36

Before a visit in Istanbul with the Turkish Suitcase Sideshow, I compiled in my journal what I had learned about using art in ministry over my years as an evangelistic street performer. These biblically based mindsets have helped guide me and other messengers of Jesus Christ not to be crushed by the temptations that being an artist can bring. What you will find in the following pages are attitudes and points of view that can aid an artist whose desire is to use their craft as more than just a trade, but as an intentional expression of the gospel. And seeing that every artist has something to say, and every person is an evangelist the moment they speak what they believe, I hope these points challenge everyone—from the rock star and the circus performer, to the youth group going to Mexico performing street mime. Surrender what you do to the greatest Creator, kill your art, take up your cross, and follow Jesus so that others can know the profound love of God.

[1] *"History of Puppetry in Britain."* October 2016, www.vam.ac.uk/content/articles/h/history-of-puppetry-in-britain.

[2] Cher. *"Gypsies, Tramps, and Thieves." Gypsies, Tramps, and Thieves*, MCA Records, 1971.

"The Lord
does not look
at the things
people look at.
People look at
the outward
appearance, but
the Lord looks
at the heart."

1 Samuel 16:7b

HEART OVER ART

QUALITY

In 2010 I was on a Suitcase Sideshow tour in Italy, the beloved homeland of the old 16th century wagon-plays that bore the rogue puppet shows of *Punch & Judy*.[3] We were coming down by train from Switzerland through Milan to Rome, and because of the mountains, the pressure change was like hitting a brick wall every time we went through a tunnel. By the time we arrived in Rome, my steamer trunk marionette theater was a total wreck. I tried to fix it, but I ended up making it worse. We searched all over Rome, trying to find parts and a backup battery-powered sound system that wouldn't be drowned out by all the city's hustle and bustle, but all we could really come up with was a pathetic boom box. We had spent hours looking for solutions, and while hoping to perform multiple shows per day, we actually only did a few in entirety. The local missionaries said, "This is normal. Everything moves slower in Rome."

For our last show, we found a park where a bunch of kids were smoking weed. It is actually believed to be the burial place of Paul the Apostle, right next to the Basilica of Saint Paul. I was told that before Christianity was legal, the early church didn't have buildings and met in houses and over the graves of martyrs outside the city where others wouldn't go. Later, when Christianity became legal, that's where they built their churches.

We started to set up, and as we did, some people came over to us and asked us what we were doing. We ended up playing soccer with them, and as we told others what we were doing, a few more came over to see our show. We didn't have a translator, so one of the kids smoking pot offered to help. It was a real privilege to do this show over the resting place of Paul the Apostle and to see other remnants of early church history, like the Colosseum; however, I couldn't help but feel inadequate about the show with my little boom box because that week we had seen some extraordinary street performers including *The Lord of the Fingers* (Marcel Gorgone on finger puppets - see page XII), and other art in Rome by Leonardo da Vinci, Bernini, Rafael, and Nicola Salvi. All I wanted was for God to use it and show these kids how different Jesus was from the religion that surrounded them day in and day out, because even though the city was full of rich art, it also screamed dead religion and empty tradition. Afterwards I gave a message about how religion is different than a relationship with Jesus, and a number of the people stood up with me to pray and ask Jesus into their lives. My translator was used by God to preach the gospel before he had even made a decision to follow Jesus. Lots of people had questions, and I knew Jesus was doing something powerful in that graveyard once again. It was a significant show that reminded me that God looks at the heart over the art.

I hear a lot of people get really irritated at Christian artists and how bad and below par Christian music, movies, and art seem to be in the industry. First of all, I disagree with the notion that Christian artistry is all below par. The famous sculptor Roy Adzak once said, "Good art is not what it looks like, but what it does to us."[4] There is good and bad art on both sides. Secondly, people express opinions such as, "Look in the Bible and how the Ark of the Covenant was this beautiful work of art. The Temple was a wonder of the world in its splendor. Noah's ark was way ahead of its time. These works of art reflected the greatest Artist in the universe, so shouldn't Christian art be leading the industry in creativity because we reflect his image too?" Well, don't get me wrong; I believe we as messengers of the gospel should always do our best as a form of worship to the true Creator. He is the source of all creativity, and we reflect his image. But, if your idea of greatness and success comes from measuring creativity by a worldly standard of tickets and albums sold, then yes, it would seem like we should be leading the industry. However, as followers of Jesus, our definition of success does *not* look that way. It looks very different. When Noah's ark, the Temple, and the Ark of the Covenant were constructed, it wasn't the art that pleased God the most. It was an obedient heart (Exodus 36:1,5 39:1,5,7,26,31,43). The workers did exactly as God commanded, and because of that, they were successful. Sometimes when we do what God asks, it will look grandiose to the eye, cutting edge, will reach thousands. Other times, it won't. It might look small, insignificant, or foolish. It might look like a street performance for a small Roma[b] community in Poland surrounded by mangy little dogs.

b *Roma* is the nationality most associated with the *Gypsy* lifestyle in Eastern Europe. The Roma are believed to have come out of northern India around 600AD and migrated to Europe. They are a nation without a home.[5]

If it is done in obedience to God, it will achieve its mind-blowing eternal impact. How wonderful a privilege it is to be a part of God's great work here on earth, no matter the size or aesthetic appeal! I can't imagine using my life and skills for anything less.

In 1 Corinthians Paul writes to Corinth explaining that, contrary to the world's thinking, "God chose the foolish things of the world to shame the wise...," so that none of us can boast—not in our art, not in our cool personalities, and not in our life-changing ideas. God uses the foolish things to confound the wise so that when powerful things happen (lives are changed, and people are healed and find hope, freedom, and forgiveness), we know that it was because of God's power, not ours. We are just honored to be used as a vehicle for his big work.

—

"Brothers and sisters, think of what you were when you were called. Not many of you were wise by human standards; not many were influential; not many were of noble birth. But God chose the foolish things of the world to shame the wise; God chose the weak things of the world to shame the strong. God chose the lowly things of this world and the despised things—and the things that are not—to nullify the things that are, so that no one may boast before him. It is because of him that you are in Christ Jesus, who has become for us wisdom from God—that is, our righteousness, holiness and redemption. Therefore, as it is written: "Let the one who boasts boast in the Lord."

1 Corinthians 1:26-31

All throughout scripture we see that God uses us not based on our own merit, but based on his merit. God uses us not because we are talented, but because he is talented. Mary, a middle school aged girl from a small town was asked to mother Jesus, not because she had a great résumé or a lot of experience mothering children, but because of her willing heart to serve. She had a willing heart of obedience to put aside her plans and her dreams and accept God's plans and his dreams for her life instead. It was that heart of obedience that God saw and was able to use. David was from the smallest tribe in Israel, a young shepherd boy with no military experience. Yet God used him to bring down a giant with a stone because of his courageous and obedient heart. God later gave him what he needed to lead a nation. Peter was a rough-around-the-edges, uneducated, typical fisherman. But Jesus chose him, not because of his creative imagination or talents, but because of his heart to follow and join Christ's mission to reach a broken world. In the end, God didn't use the disciples because of their skills, but because of *his* skill to make all things new.

The same is true for us. Our art, skills, and everything we have are wonderful gifts. We should hone them, grow them, and make them the best we can. But they're not what will change lives and ultimately the world. Without a heart of obedience and courage that chases after righteousness and aligns itself with Christ's mission, it doesn't matter how talented you are; you will never achieve your fullest potential, because true success is a matter of the heart, not the art.

I once met a lady who was heavily involved in the Burning Man Festival and had radically given her life to Jesus after coming out of paganism. She was a talented painter, but at the time of our encounter, she had stopped painting altogether. When she came to Christ, she felt God

telling her to stop and surrender all her art to him because it was being used by dark forces to work in her life. I asked her to paint for me a realist portrait of a marionette for my Suitcase Sideshow trunk. She told me she would pray about it but that she hadn't painted in a long time, and besides she had never done anything realist, only abstract. The next time we spoke, she said she had felt God saying, "Now is the time you may paint again." But this time it would be for him, and in a new way that she knew she couldn't do in her own strength. She gave her gift back to God, and he changed her life and used it as an outlet for healing. He did something with her that she could have never done on her own because he is the greatest source of life, power, and creativity. She killed her art, and God gave it a new life that was better than before.

After reading about the notion that God looks at the heart over the art, I imagine someone could draw one of two conclusions. One response could be that because we lean on God's power, not the quality of our craft, we don't really need to hone our skills as Christian artists. The other response would be to continue working to develop our abilities while understanding that the quality of our art is not what will determine eternal results—rather it is the Holy Spirit working in and through us. I hope it is the latter of the two responses that you choose.

We need to never dismiss the fact that we have been given a part to play, which should lead us to always do our best, because that is what God wants (Colossians 3:23). He can use whatever we give him, but he still deserves our very best. The builders of the ark and the Temple were extremely skilled at their work. As a prince of Egypt, Moses would have received the best education in Egypt. God put Daniel in a position to earn favor with his enemies based on his incredible knowledge, wisdom, and heart. Paul was

schooled by the best in language and religion, and God used his education and training to spread Christianity across Europe. There is nothing wrong with becoming your best at something and not compromising the quality of your art, as long as it does not become your identity and your priorities are in the correct order (God, family, ministry, self).

It is true, God looks at the heart over the art, but initially people do not. They respect a thorough presentation and will appreciate you even more if you give them a real creative gift. So we do our best, not for pride in ourselves, but in humility and worship to our Creator, our Audience of One. We kill our art, gratefully understanding that anything eternal that comes from our work is because of God's power, not our craft.

—

"Now to him who is able to do immeasurably more than all we ask or imagine, according to his power that is at work within us, to him be glory…"
Ephesians 3:20-21a

[3] Collier, John. *Punch and Judy: A Short History with Original Dialogue.* Dover Press, 2006, p. 9.

[4] *"Roy Adzak Quotes."* Aug. 2016, www.art-quotes.com/auth_search.php?authid=576#.V64ptnAq68k.

[5] Fonseca, Isabel. *Burry me Standing: The Gypsies and Their Journey.* Vintage Departments, 1995, pp. 72, 83-112.

"They exchanged the truth about God for a lie, and worshiped and served created things rather than the Creator—who is forever praised. Amen."

Romans 1:25

ART AS AN IDOL

PROCESS

When I was in high school, I developed an interesting knack for writing creepy circus music. It was as easy as breathing. The music would come to me on vehement night winds as I stayed up late into the evening under candlelight. I would compose harmonious melodies that evoked images of harlequins dancing in celebration. I wanted God to use my gift, but I couldn't understand how that would ever happen. I couldn't imagine people worshiping to creepy circus music in church (not yet at least, but this is something I am still seeking to rectify with my accordion and one-man band getup).

I moved to Minneapolis and was asked by a local ministry called the Scallywags Bike Club to write the music for an evangelistic circus they had been dreaming about for some time. I was completely shocked by the love of God, that he had seen my eagerness to use my gift for him, and then led me to the very people to

make it happen. I fell in love with the project and began to envision grandiose scenes of insanity, a huge circus band wearing strange masks, and spectacles that would taunt and tickle everyone's wildest emotions. It was called *Madness of Folly*, and it would be great and completely foreign to Christian music, hopefully taking it to the next creative level. At first, people just started coming out of the woodwork to help. The buzz and the vision were contagious. The circus wagon was built and painted, strange people with strange talents surfaced, and rock musicians realized they could pick up that old marching band instrument again and make it cool. But then we had a "come to Jesus moment," when we remembered what this circus was really for and realized who should be involved. This circus was for spreading the gospel to small towns and going to places outside the church to reach people who would never step foot in a church. It wasn't meant to revolutionize the Christian music industry or be anyone's platform for fame. We didn't want to see ourselves as great artists; we wanted to see ourselves first as missionaries. So, when those who disagreed with the purpose of the project discovered this, or when their lifestyle didn't match the calling, one by one, talented people with the wrong hearts resigned. I then realized that all those great ideas I had for this big circus band playing the ultimate creepy circus music were no longer going to be possible. I was faced with the question of where my heart was as well. Would I still do it? If it was just my accordion and the show was really dull and completely unimpressive musically, would I still do it? Is the gospel enough?

I was brought back to the story about Abraham and Isaac (Genesis 22). God had given Abraham a gift and a promise. He was going to father a nation even though he had no son. Then, through a miracle in old age, he was

given a son he named Isaac, whom he loved greatly. But then God asked Abraham to put his faith in God and his love for his son on the line by sacrificing his son. I saw myself as Abraham being asked to put my faith in God and my baby, which was my art, on the line as well. I saw Abraham getting life from his baby, and so was I. He was posed with the same question I was: Is God enough?

A lot of artists see their art the same way Abraham might have seen Isaac. Our art is our baby. We love it. We want it to do well. We want it to make its fullest impact on society, and we want to see it succeed. We hope it will support us in our old age and outlive us. We get life from it. It has become an idol to us. But are we willing to put it on the chopping block and make changes in our art and cut it down for the sake of the gospel if it means the good news of Jesus will go forward? Even if it means we won't look very cool, or the art will be misrepresented and our name will be tarnished? Are we willing to let go of our pride and our baby for the sake of the gospel and trust God's goodness? Is the gospel enough?

Once I realized that God was speaking to me and I had a choice to make, I made it. I said, "Yes, the gospel is enough. Even if I have to play my accordion all by myself and I look stupid. If the gospel goes forward and people are touched, then I will do it!" I let go of my art as my idol on that day. I killed my art, gave it to God completely, and decided I would not get my life from my art anymore, but instead from walking in obedience and service to my Lord. Abraham did the same thing. He brought Isaac up to the mountain to be sacrificed. He also decided that God was enough. But once God saw this, he provided a blessing in the form of a ram to take the place of Isaac. I was also given a great blessing. I began to meet new people who had the right heart for what we were doing. Sure, the

show wasn't going to be exactly the same, but because God is the source of all creativity, he knows how to give us new ideas and equip us with everything we need to do his work. The show must go on, and it did!

God calls us to kill our art by letting go of our idols, even if it means being uncool in order for him to move. It isn't because God wants to stop us from being good at our craft or deprive us from having a wild production. We should always do our very best as unto the King of Kings. It's just that he knows what will bring life to us and our work, and what won't. Art was not meant to fill us in the way that only God and his love can truly fill us. He knows this and wants us to trust him so that he can do a wonderful work through us. He wants to do through you what you could never do on your own. But we must get our priorities straight and be willing to let go of our idols in order to allow the greatest Creator to have his way. He knows how things need to go. God and the gospel are enough.

(For more on this story, see Generation 4 in the book *Travelogues of a Family Sideshow*.)

—

"Be appalled at this, you heavens, and shudder with great horror," declares the Lord. "My people have committed two sins: They have forsaken me, the spring of living water, and have dug their own cisterns, broken cisterns that cannot hold water."
Jeremiah 2:12-13

"If anyone causes one of these little ones—those who believe in me—to stumble, it would be better for them if a large millstone were hung around their neck and they were thrown into the sea."

Mark 9:42

DIRTY LAUNDRY ART

CONTENT

Art has always been a place for protest. When something is wrong in the world and needs to change, or when someone has been hurt, we feel the urge to vent or create something that truly shows how we feel. Sometimes it's a canvas or a song that helps us process our feelings and deepest struggles. Banksy, one of my favorite graffiti artists, immediately comes to mind. He has an incredible ability to convey such a powerful message using the most ideal imagery in the perfect location. I think this capacity is something God-given about art that certainly shows humanity's uniqueness in creation. God gave us creativity as a vehicle for many reasons, and sometimes it's a means for protest and healing. But when given a platform of public influence, I believe there is a responsibility that comes with it. Being a proper steward and caretaker of the influence you have from the stage takes a great amount of wisdom, which artists (and the industry that supports artists) oftentimes lack but desperately need.

In Frances Schaeffer's book *Art and the Bible*, he points out that Christian art should always reflect hope, because that is what we ultimately have in a world that seems so "bent on destruction." He writes, "...[T]he Christian and his art have a place for the *minor theme* [the abnormality of a fallen world] because man is lost and abnormal.... But the Christian and his art don't end there. He goes on to the *major theme* [the meaningfulness and purposefulness of life due to God's existence and presence with us] because there is an optimistic answer."[6] No matter what the situation or struggle we face in the present, we have hope in it all. Hope not in ourselves or in humanity—which isn't much to stand on—but hope in a greater love and a greater good that is victorious, just, and all-powerful, founded on Christ Jesus our Lord. Somehow our art needs to reflect this hope even within the struggles of life, because that is what separates Christians from the rest of the world. This may be the same reason why many people who do not understand our worldview, which is founded on hope, don't see our art as very "good." This may be why they sometimes see our art as "cheesy" or "unrealistic." They just don't understand the hope we have, and therefore, they can't relate to the art. This is something I will cover in a following point, "The Art of Resourcefulness," to explain how we can better show this message of hope in ways others can understand and receive.

The secular worldview alone does not have true hope. They have relativity, nihilism, and meaningless existentialist answers that claw and scratch at the edges of life looking for purpose and justification. In terms of storytelling, some cultures in the East even hold a tragic ending in higher regard than in a hopeful ending. In their eyes, this kind of ending is more "realistic" than optimistic endings that we see more commonly in the West. Hope

is what separates Christian art and our worldview from secular art and their worldview. Jesus is still the same when our lives are crumbling beneath our feet and everything is hitting the fan. He's still madly in love with us, on our team, and aggressively working to make all wrongs right. He cries when we cry and laughs when we laugh. Unfortunately though, many Christian artists get caught up in the moment of that bad experience at church, a leader who failed them, or a struggle with other Christians, and in an effort to process and just be honest, they lack wisdom in only giving half the picture to their audience. Thus their influence leads the public towards a conclusion that only contains half the story and is without hope.

As artists who are called to be messengers of Jesus Christ, we should kill our art in this area and choose to not publicly air our dirty laundry art for the whole world to see if it will negatively impact their view of Jesus. Our art and our message should reveal hope because that is the full truth we ultimately have. Anything less than that is a lie or, at best, a half-truth that could lead people astray, even if it is all dressed up in honesty and good intentions.

—

"Do not let any unwholesome talk come out of your mouths, but only what is helpful for building others up according to their needs, that it may benefit those who listen."

Ephesians 4:29

Today honesty and authenticity are held in high esteem. I think that's great, but there is a point where honesty is no longer loving. For example, let's say a husband and wife are getting ready to go out on a date

to the theater to see *Cats*. The wife found a new dress she absolutely adores that matches a vintage pair of shoes she has wanted to wear for a long time. After putting on her makeup and doing her hair, she asks her husband, "How do I look?" He now ignorantly replies by saying, "I think you look fat." That would probably not be the most loving thing to say. The evening mood would be shot, and in his ridiculous defense, he would probably continue to dig his grave by replying, "What? I'm just being honest." Marriage Counseling 101: Choose words that encourage and show love. There is a point when we can be so brutally honest, that it becomes more about us and getting something off our chest by using others as a canvas for our vomit, than about loving those who are poised before us to hear us out. Honesty without kindness is not loving. Jesus has called us to love others no matter what and never to say or do anything that would make it harder for them to choose to follow him, or would cause someone to turn his or her back on him. This includes our audience.

In 1 Corinthians 6 Paul addresses a problem in the first century church where Christians were taking each other to public court for the whole city to judge, scrutinize, and gawk over. He scolds them because they should be able to work out their struggles within the church where it can be dealt with everyone's best interest in mind. This includes the best interest of the public, so they don't foster an incomplete understanding of God based on a partial story. How often do we see Christian musicians and poets taking other Christians to court before an easily influenced audience, in the name of sincerity and honesty? There are so many bands that come to mind that I just won't mention right now. On social media it's become a worldwide epidemic. I'm not saying that when the law is broken, it shouldn't be dealt with according to the law of the land, and I'm not saying we should never

write about our struggles. If we need to paint or write music to process and grow, that's great. But once given a platform of influence, we need to be proper stewards of the platform we have been given and use it in love to better serve people and steer them towards Jesus, rather than our own self-centered needs.

—

"If any of you has a dispute with another, do you dare to take it before the ungodly for judgment instead of before the Lord's people? Or do you not know that the Lord's people will judge the world? And if you are to judge the world, are you not competent to judge trivial cases? Do you not know that we will judge angels? How much more the things of this life! Therefore, if you have disputes about such matters, do you ask for a ruling from those whose way of life is scorned in the church? I say this to shame you. Is it possible that there is nobody among you wise enough to judge a dispute between believers? But instead, one brother takes another to court—and this in front of unbelievers!"

1 Corinthians 6:1-6

Let me give you an example from the secular music industry. There are a variety of examples of pop artists who have been given a platform of incredible influence within our global society not based on their wisdom, but on being

youthful, shocking, sexy, and talented. Maybe they are allowed to just "be themselves." Maybe they are just being "honest," but the direction they are leading our moldable youth is the opposite of where a wise, loving father who cries over his children would ever lead. That influence has already, and will continue to, spiral our society further into harm's way. Unfortunately, the same can also be said for some Christian artists who are picked up by labels and churches for their talent, instead of for their character and spiritual integrity. To whom are we offering the powerful stage of influence and instruction?

—

"Not many of you should become teachers, my fellow believers, because you know that we who teach will be judged more strictly."
James 3:1

I understand this subject may be hard for many Christian artists to hear and could tug at the very fabric of what they love to do with their art. It's your right as an artist (at least under most un-oppressive governments) to say what you want. But it's also our privilege as followers of Jesus to lay down our earthly rights for others, die to ourselves, and kill our art by truly loving our audience more than our art and obeying the last words of Jesus, which were to go into the whole world and preach the good news. This may feel hard, unnatural, or forced to the artist who does not have a sincere, broken heart for people. You can read all the books in the world on the subject, but unless Jesus gets hold of your priorities and you truly get his broken heart for the lost, this book might actually be one of the most offensive books you will ever

read. And by no means do I intend to guilt anyone into doing anything out of a new legalism! What good would that do? What it will actually take is not reading any more books, but instead sitting alone in your quiet place with God's Word, getting exposure to the desperate need in the world, and going for a walk with Jesus and asking him for his broken heart. It will change you if you do that. It might get scary. You may end up joining me and others in killing your art; but only then, like a seed going into the ground, will it be resurrected and born again into a new creation and reach its fullest, God-given potential.

Show your audience your struggles. Show them the world's darkest secrets. Don't hold anything back about the real evil we see every day, or the pain and brokenness we all try to escape. But in the end, love your audience by finishing with hope. Finish with the cross and the promise of new beginnings established by the resurrection, and you will see people understand your pain more deeply, as well as the solution you have found in Christ Jesus alone.

I first received the calling to create the Suitcase Sideshow marionette theater after a pleasant sit-down with a renowned puppet maker in Minneapolis whom I had great respect for. He had a studio full of ancient puppet props above an old shoe store on Lake Street. Everything had a story. I had been asked to work with him as a composer for one of his shows. We talked for a while, and ideas were just ablaze. I couldn't help but notice different suitcases around his studio. He had done street puppet theater in Mexico, inspired by a priest who used to dress up like a clown and perform sacraments out of a suitcase. I was planning a trip to Brazil to serve the poorest of the poor as well, and I had thought about what I should do there. This idea of a steamer trunk that could open up into a miniature theater with self-contained

lighting and sound began to resonate within me more and more. It included all the forms of art that I knew and loved, ranging from musical composition, theater, storytelling, performance, and puppetry. But then I was faced with the biggest question of all: What should I say? What should the show be about? If I could say one thing to a prostitute or a street kid living in a slum sniffing glue, what would that be? What *should* it be? Should it be something I have had on my chest for a while? Should it be a feel-good song with only half-truths in order to not rock the boat too much but missing the opportunity to bring some kind of meaningful hope and change to this desperate situation? Should it be a made-up answer to a problem that I really know nothing about? I prayed and fasted and asked God to come into my art and give me his heart. All I could do was remember the apostle Paul—that he was a murderer who hunted down Christians and was totally changed. If God could change his life (and mine, too, for that matter!), then that means nobody has gone too far from God's love that he can't change their life and give him or her hope as well. So that became my mission going forward from that moment. If I had one thing to say to anyone, it would be the gospel. It would be that you are worth dying for and that nobody has fallen too far from God's love. Now that's worth making art about. What happened after that changed my life.

—

"Do nothing out of selfish ambition or vain conceit. Rather, in humility value others above yourselves, not looking to your own interests but each of you to the interests of the others."

Philippians 2:3-4

| 6 Schaeffer, Francis. *Art and the Bible*. InterVarsity Press, 1973, pp. 83-87.

"Consider it pure joy, my brothers and sisters, whenever you face trials of many kinds, because you know that the testing of your faith produces perseverance. Let perseverance finish its work so that you may be mature and complete, not lacking anything."

James 1:2-4

ART AND THE STRUGGLE

PERSEVERANCE

There is something about life's struggle that makes great art and truly puts the human spirit in a well-crafted street performance. Charlie Chaplin's early film, *The Vagabond* (1916), captures a beautiful look at life's struggle through the eyes of an early 19th century homeless busker. In Roman times, it's recorded that sailors would sing of their misfortune at their seaports to earn money.[7] Can you imagine the haunting stories those old sailors must have sang about? Among my own friends, I have seen many who are on the cutting edge of culture, but have to live in their art studio and scrape by eating out of dumpsters. Many artists who are household names today lived in poverty and had truly humble beginnings. It's the realness of raw emotion that inspires some of the most powerful creativity. Ultimately though, I don't think anyone wishes to remain stuck in such a place, and being properly funded like Michelangelo or Bach is really the true dream. There might also be a few other variables contributing to their poverty (addiction, fear, pride), so I won't glamorize their situation.

Throughout the years as an evangelistic street performer, I have learned that too much comfort and no struggle can easily cause me to stop living by faith when it comes to my art and my life. Things get easy, and we can begin to believe the lie that, "I've got this." But as messengers of Jesus Christ, we need to keep taking new steps of faith and never stop believing that God can do more. Otherwise our art and our ministry will become stale, and we may forget the realness of being desperate for Jesus. It's easy for us to want to get comfortable. It's natural, especially as we get older and want to slow down and settle down. And it's a good thing to feel safe and at peace, but when it doesn't come from the Lord but instead from all the temptations the world has to offer, we can easily lose that spark and inspiration. It's pretty clear from scripture that our main goal here on earth is *not* to just live a nice comfortable life that doesn't cost us anything and then die. No! Put on that armor of God and fight! Give all that you can, surrender everything to God, love selflessly, and live courageously. That isn't usually comfortable, but it's an exciting life worth living.

Among my comrades, we have a saying: "Nothing of value happens without a fight." Unfortunately, among Christians today, I hear too much of an emphasis on everything just falling into place, and if it doesn't, then God must not be in it. There seems to be laziness about prayer when facing trials. It's true that when God is in something, he can provide everything and things do sometimes fall into place, but making that your life motto can actually create lazy followers of Jesus. I don't see too much falling into place for Paul, Peter, or James. They had to depend on God for everything through the struggle. If God didn't come through for them or others in the early church, they were in trouble; their writings reflected their perseverance and

dependence upon God. Having the view that there is going to be a fight to see your art used by God will cause your prayer life to be more robust.

When I was in my 20s, I had a classic case of wanderlust. I wanted to see the world, and God used that desire to introduce me to global missions after I was faithful locally. People would say, "Good, travel when you're young." Then on one certain tour with *No Longer Music*^c, we were in Turkey being followed by the secret police and having rocks hurled at us. We were setting up our production in the center of a city, not far from Iraq, and the police were actually telling the kids to throw rocks at us while pretending to protect us. They were setting up surveillance cameras on the rooftops, and we saw a tank come by and park around the corner of an adjacent building. I lost my wanderlust on that day and decided that whatever I did moving forward on a global level was going to be out of sheer obedience, not wanderlust.

Later I got married, and we wanted to buy a house, but it wasn't God's timing. We gave up that dream, quit all our jobs, and started traveling full-time in Europe performing our show. People would say, "Good, travel when you're young before you have kids and a house." Then when we came back, God blessed us with better jobs than before and a house that wouldn't hold us back from missions, but helped us even more. We continued to travel and then had kids and took them with us.

Each step got harder and harder. During each stage of life, it would have been more comfortable to say, "That's enough," or reminisce about the way it used to be in the "golden age." But we have decided that this was part of

c *No Longer Music* is a world traveling evangelistic rock opera founded by David Pierce of Steiger International.

our worship and family calling; and until God shows us something else, we won't form our lives around comfort, but instead around God's calling in our lives—no matter what shape it takes or what trials we encounter. That calling will dictate where we live, how we spend our time, and how we raise our kids. We do not want to be controlled by the rat race, the American dream, weather patterns, tradition, or anything else.

In Matthew 8:28-34, there is a story of when Jesus cast a legion of demons out of a man into a herd of pigs. We often read this story and see it from the perspective of Jesus and the man who was delivered. I think that is a good way to approach it, because that is the angle from which it was written—but what about the herdsman who owned the pigs? Those pigs were his livelihood and his employment. Jesus cast those demons right into the very thing that was going to provide food for his family. Was that very nice? No wonder he asked Jesus to leave the region. But what if instead, casting the demons into his pigs wasn't seen as a curse by the herdsman, but as an invitation? When Jesus shows up, it's likely to get uncomfortable. What if, having seen the power of God displayed, instead of getting frustrated with losing his herd of pigs, he had joined Christ's mission along with all the other followers who had given up everything to follow Jesus? What if, given his new circumstances, he took a step of faith and followed Jesus? I don't think God would have neglected him or not taken care of his family. It might have been hard at first, but it would have turned out better than before.

The same is true for us. When Jesus shows up, it's likely to get a little uncomfortable. It's that discomfort that causes us to have more faith and lean on Christ for even more help. Too many churches and movements die because they started with a blast of faith because God did

something radical, and then they just ride that wave. They keep telling the same stories over and over from how this thing got started. They are always reflecting on the good old days, or the golden age. But they aren't willing to take another step in surrendering to God's leading and risk losing it all, even though that kind of trust and obedience was what sparked God's action in the first place. It's that step of faith that keeps the movement alive and fresh. It keeps you desperate for God to move, because if he doesn't, you're screwed.

—

When he arrived at the other side in the region of the Gadarenes,[a] two demon-possessed men coming from the tombs met him. They were so violent that no one could pass that way. "What do you want with us, Son of God?" they shouted. "Have you come here to torture us before the appointed time?" Some distance from them a large herd of pigs was feeding. The demons begged Jesus, "If you drive us out, send us into the herd of pigs." He said to them, "Go!" So they came out and went into the pigs, and the whole herd rushed down the steep bank into the lake and died in the water. Those tending the pigs ran off, went into the town and reported all this, including what had happened to the demon-possessed men. Then the whole town went out to meet Jesus. And when they saw him, they pleaded with him to leave their region.

Matthew 8:28-34

We take a step of surrender every time we perform. We never know what will happen. It's like taking the step

that Joshua took into the Jordan River, believing it would part. It's a fight every time (Ephesians 6:12). Sure, once we find a place where the show does well, we keep going back, but we still never see the same outcome twice. We are always exploring new territory and new creative ideas that will require more faith, like taking our heirloom marionettes all over the world.

We have been traveling the world for years with the same marionettes my grandparents traveled with back in the 1960s. People ask us, "Don't you worry about the puppets being ruined? Why do you use your heirloom, antique marionettes to go into places that may be dangerous?" The reason is simple. Because in those places dwell individuals who are worth so much more than the value of all the marionettes in the world. Yes, you could go in with puppets that are junk, knowing that they will probably be destroyed anyway, but that only fuels the lies that haunt them at night. That only fuels the thoughts that those people are also junk and aren't worth the value of a sacrifice—that they are dirty, and that we can't risk losing what is important to us because they are not worthy. No! We would kill our art for them. People are not junk, and to them we give our best. These puppets were designed many years ago for the single purpose of sharing the love of Jesus, and they will probably meet their end doing what they were created to do. Without that purpose in mind, I think these puppets just don't have the same value. It is worth the discomfort of losing material possessions in order to share with someone from a brothel or underneath a bridge that they are not an accident and that their life has value. Our willingness to share our treasured possessions tells them, "You are significant, and we want to use art that has significant meaning to bring you some laughter, a moment of sanctuary, and true peace!" This gift is so

minute in comparison to the significance of what God has already done for us. He sent his most prized possession, his only Son, fully knowing what would happen to him, to be in human form and die on a cross in order to provide a way for our undeserving selves to once again have a relationship with our Creator, just like it was intended. That is worth making art about, no matter the struggle.

We're in a spiritual war here. Face it. Don't ignore it. I've seen people fall—good people, people I never thought would. But the coolest thing about being in this war as a busker is sticking it to the enemy every time we can blast truth, love, and hope to a world that is suffering and being fooled by all the constant static in the street. Live life! See people get rescued! Join the ride and see God work when you kill your art and surrender all you have to the greatest movement of all time, no matter the struggle.

[7] Cohen, David and Ben Greenwood. *The Buskers: A History of Street Entertainment*. David and Charles, 1981, p. 12.

"I am sending you out like sheep among wolves. Therefore be as shrewd as snakes and as innocent as doves."

Matthew 10:16

THE ART OF
RESOURCEFULNESS

METHOD

In my early days of performing with the Suitcase Sideshow, I used to enjoy a riot once in a while at my shows. I still kind of do, though I think I have matured a little bit since then. But if I ever miss it, I know exactly where to perform and what to say; and sadly, it happens to be mostly in my own city. I get a little bit of a charge when the crowd is angry against me. It's kind of a rush. I get more desperate for God and for him to give me courage and protection, because if he doesn't, I could be in big trouble. It feels like I can almost literally taste the spiritual battle going on, and I love that. So far, I have been very fortunate to have been protected and have not been thrown off any cliffs or actually beaten up. I have had a few close calls though.

One time, I sent my show to the Rainbow Gathering, which is an epic hippie gathering in the middle of a national forest. They gather yearly to get high on everything and dream of world peace. I didn't go because I was on tour with *No Longer Music*, but I prepared others to take the show with our church ministry, the Jesus Kitchen. Before they went, they performed at a café on the West Bank of Minneapolis. They had received permission from the barista but after a shift change the next barista didn't like the show and turned up the radio full blast to try and drown it out so nobody could hear the words of Jesus. Then during their first show in the woods at the Rainbow Gathering,

someone ran up to tackle the performers, and one of my other friends had to restrain him first to keep him away. The hippie peace festival was the first time we needed to tour with bouncers. Someone else took a trumpet and tried drowning out the dialogue that was being spoken by Jesus so nobody could understand what was being said. I don't think the person lasted the full 25 minutes of the show. So I can only imagine the humor in his final attempts while the soundtrack was still going loud and strong.

Another time we performed outside a punk squat in Bern, Switzerland, where everyone was shooting heroin. The locals told us that this place was notorious for hating Christians. The punks spoke out against Christians and would commonly rob people at needlepoint, threatening them with AIDS. We prayed long and hard about whether or not to do the show, but after hearing from God on it, we did. Before setting up, we talked to everyone doing drugs and selling drugs and asked them permission to do the show, telling them it was a story about hope. Then we set up and performed like normal. Halfway through, someone in the back yelled at us, "I don't believe in this!" He then rushed us, and I thought, "Okay we're done for." He stopped about nine feet from us, sat down, and watched the rest of the show. We had some great prayer and conversations with people afterwards, and a local ministry continued to reach out to that place for a long time after we left. (See the chapter "Sorrow Masked with Beauty" in the book *Travelogues of a Family Sideshow*.)

Then there was the time when we did a show in The Rock Galleria in São Paulo, Brazil, which was a big mall dedicated to underground music cultures. We set up between a couple of sex shops on the fourth floor right on the edge of a balcony overlooking the street. It was only my third or fourth show since one in Minneapolis at

an underground punk rock theater. In Minneapolis the crowd had erupted into the biggest riot the venue had ever seen, even though they were known for controversial acts. People were up in arms, throwing beer cans and screaming at a puppet show. Afterwards we were escorted off stage. Because of that response and the balcony, the first thing that went through my mind at The Rock Galleria was when Jesus spoke to the people in the synagogue, and they tried to throw him off a cliff (Luke 4:16-30). I didn't think it would be that hard for anyone there to pick up my stage, and possibly me too, and throw us off the balcony altogether. That would have been the end of it. Thankfully, that didn't happen, and even though we had permission from the mall to perform, by the time security showed up to shut us down, we were finishing up.

Today, my desire isn't to generate a riot or cause an uproar. My goal is for people to come to Jesus and to present him to people in a way they can really understand and receive, not just get angry about. This has actually been my goal all along, but I think I am just getting wiser at how to go about that. I am also getting better at surrendering my art and allowing the Holy Spirit to change it to be more effective. But no matter what, there will always be people who are blatantly against the gospel. No matter what you do, there will be baggage from their past and false beliefs they hold about Christ. However, there are things we can do in our presentations that will hopefully do away with many of those barriers and present Jesus in a way that scoots around some of that angst, the same way Jesus scooted around the angst of the Pharisees with his stories that we call parables.

In Luke 8, Jesus tells the story of the sower who went out to sow seed in his field. Some seed fell on the path and was trampled and eaten by birds. Then some fell upon the

rocky ground and withered due to lack of moisture. Some were choked by thorns and weeds. Then finally some fell upon the good soil and grew up to produce a harvest. After the story the disciples asked Jesus what he meant, and he said something very interesting about the purpose of his parables.

His disciples asked him what this parable meant. He said, "The knowledge of the secrets of the kingdom of God has been given to you, but to others I speak in parables, so that, "'though seeing, they may not see; though hearing, they may not understand.'"

Luke 8:9-10

It sounds like Jesus is allowing some people to understand these stories and some people to not understand—and that is exactly what Jesus is doing, except that it is still the desire of God that all people may know Jesus as Lord (2 Peter 3:9). The problem is that so many people have already determined in their minds to be against Jesus and, like the Pharisees, are not aiming to understand or seek truth, but to disrupt and cause a ruckus for those who are genuinely seeking. Early on in Christ's ministry, people were flocking to him as he healed them and spoke freely of the Kingdom of God; but as his reputation spread, his increasing popularity among seekers was matched by his unpopularity among haters. So he tactfully began to use parables from culture that would both reveal truth to those who were seeking and had open hearts, as well as confuse and diffuse conflict among those who were not seeking

and only wanted to disrupt. As artists and messengers of the Gospel, we too should be more discerning in our teaching methods and stories in order to discover those who are seeking truth, while minimizing skepticism among those who are not, just like Jesus did.

The following points are an ever-growing, incomplete list of ways I, and others I have learned from, have surrendered and killed our art to be more resourceful in presenting the love of God in ways people can understand. Of course this probably goes without being said, but I'm going to say it anyway: None of this will ever stick unless it is fused with and bathed in prayer. No matter what concoctions we come up with, without the power of the Holy Spirit giving us wisdom in every situation, none of this will hold any weight. I have seen countless people come to Christ with and without many of these methods. Even when I have been unable to implement them myself and I have had to rely solely on the grace of God for anything good to come out of what we do, I have seen people find hope and freedom in the message of Jesus. So, that being said, the following may be called actions of obedience that have produced fruit that others can learn from to implement within their own art.

Shock Treatment

—

"But I want you to know that the Son of Man has authority on earth to forgive sins." So he said to the paralyzed man, "I tell you, get up, take your mat and go home." Immediately he stood up in front of them, took what he had been lying on and went home praising God. Everyone was amazed and gave praise to God. They were filled with awe and said, "We have seen remarkable things today."

Luke 5:24-26

It's pretty obvious that we live in an age of information. Google makes it easy to gather information from anywhere. We want to be in the know, and we can be pretty easily. As I've traveled around the world, it seems that we are all becoming more and more one global culture surprised by less and less, thanks to the internet. But, when people are surprised and shocked, you've got them. If you can surprise people with your presentation, you will keep their attention. Their hunger for posting videos of new things on their phones and the desire to be well informed is uncontrollable. That's why, as hook-and-bait as it might sound, shocking people is one of the best attention getters out there, and I'm no genius for saying that.

All sorts of people shock their audience to gain their full attention. Dynamic public speakers do it all the time to gain a large group's attention, and secular artists and

producers know it and do it too. Shock treatment can be used in terrible ways in pop culture, like gaining the attention of young kids through sex. It's gotten so bad that it's numbing our inner moral senses. But I believe that with a bit of humor, fire breathing, giant bubbles, insane countercultural kindness, or old-fashioned creepiness, we as messengers of the gospel, can also use our art in a way that will shock people enough to gain their respect and give them something interesting to chew on so they want to hear more of our message. Jesus and his disciples used miracles to shock people and get their attention all the time. This is definitely the best option, but if the Spirit isn't leading you in that direction, your art is another option and a different kind of miracle that could be part of God's plan as well.

Near the beginning of our show *Blessed Are the Poor*, we present a legalistic religious man boastfully praying a really creepy prayer full of self-righteousness. One time a kid came up to me after my show and told me that the show scared him and gave him bad dreams. Later his mom emailed me and told me that the show had actually really kept his attention and he decided to give his life to Jesus that night.

I've seen other unique acts open their show with crazy music and drama with insane declarations that serve the purpose of catching the audience's attention. And this "shock treatment" works. It makes people wonder, "Where in the world is this going? I want to find out." Art galleries can do a great job at this by asking exceptional, thought-provoking questions that challenge people's wrong impressions of Christianity and God. Magicians thrive on the wow factor by reading minds and cutting people in half. Whirling one-man bands in Chile gather huge crowds by literally putting a new spin on their performance. Jugglers,

contortionists, and acrobats don't have an act without something death-defying. I think it would be healthy for us as messengers of the gospel to lead the way in being less boring in our approach to evangelism and much more resourceful and surprising in how we communicate with our art. What if there were even a tenth as many fire breathing sword-swallowing preachers, as there are Christian guitar players? That might turn a few heads towards Jesus. Let's take *ourselves* a little less seriously and the *gospel* way more seriously.

The Cultural Vacuum

"Though I am free and belong to no one, I have made myself a slave to everyone, to win as many as possible. To the Jews I became like a Jew, to win the Jews. To those under the law I became like one under the law (though I myself am not under the law), so as to win those under the law. To those not having the law I became like one not having the law (though I am not free from God's law but am under Christ's law), so as to win those not having the law. To the weak I became weak, to win the weak. I have become all things to all people so that by all possible means I might save some. I do all this for the sake of the gospel, that I may share in its blessings."

1 Corinthians 9:19-23

When Jesus walked the earth, he called people to four things pertaining to faith: repent (Matthew 4:17, Mark 1:15), believe (John 3:16, 8:24), change (Matthew 18:3, John 14:15), and join Christ's mission (Matthew 28:16-20, Luke 24:44-53, Mark 1:17). We, as messengers of the gospel, sum up these four things as "being born again into a relationship with Jesus by asking him into our heart" (John 3:3, 2, Corinthians 5:17, Romans 10:9). If you lay out the gospel in the simplest form you see that God created the

world perfect and without death. Humanity screwed it up by joining death, separating ourselves from our Creator, and believing and acting upon the lie that we can be like a god. We were corrupted by evil. But God did not abandon us. He entered into the world by establishing his Kingdom as a man and taking our death sentence on the cross. Then he defeated death, recreating the perfect fellowship we once had with God through the resurrection and the forgiveness he offered. Now he calls us to join him in his mission of spreading this good news and further building his Kingdom of freedom, justice, and love[d]. This is the gospel, but because of so many different filters and worldviews, it is hard for people to really understand and see Jesus for who he truly is. That's why I believe it's important that we creatively display the gospel in ways that people can clearly understand by finding common ground that will open the door to their hearts.

Culture creates vacuums or empty spaces when other areas develop to an extreme. For example, when there is too much judgment, there becomes a vacuum or an empty space for acceptance. Where there is too much control, there grows a vacuum for freedom. Where there is oppression, there grows a vacuum for a revolution. These can be areas of "good news" within a society that provide common ground for sharing the gospel. Typically, societal forces like bands, corporations, politicians, lobbyists, and celebrities create and counter-create vacuums in our ever-changing culture. They try to provide answers to our needs, but their answers keep leading us to other forms of emptiness. And since the only real answer for our world is Jesus, Jesus needs to be seen as the true answer that

d A good resource for sharing the gospel in simple terms is called The Big Story, taken from James Choung's book, *True Story: A Christianity Worth Believing In*.

people are really seeking in the cultural vacuums of life that we face. He is the perfect fit for our hearts that won't leave us with that empty feeling anymore.

—

Jesus answered, "I am the way and the truth and the life. No one comes to the Father except through me."
John 14:6

Jesus answered the vacuum of religious oppression in his day by creating a path connecting directly to God through freedom from sin. To the sick, he was the Great Physician. To the shepherd, he was the Good Shepherd. To builders, he was the Cornerstone. To those in darkness, he was the Light. To those who were hungry, he was the Bread of Life. To those who were thirsty, he was Living Water. And to the rolling stone, he was the Rock! This is the gospel— the "good news" the human condition still longs for and may accept when we tactfully show Jesus as the answer to the modern vacuum that people are seeking. After we show them Jesus in a way they can understand, they may see their need for him and be willing to humble themselves and follow him.

In Acts 17:16-34 Paul addresses the Athenians and shows them who Jesus is through their own beliefs. He didn't explain Jesus to Greeks as if they were Jews; he explained Jesus to them from a Greek perspective as the "unknown god." That way they could understand and see the need for Christ in their lives.

While Paul was waiting for them in Athens, he was greatly distressed to see that the city was full of idols. So he reasoned in the synagogue with both Jews and God-fearing Greeks, as well as in the marketplace day by day with those who happened to be there. A group of Epicurean and Stoic philosophers began to debate with him. Some of them asked, "What is this babbler trying to say?" Others remarked, "He seems to be advocating foreign gods." They said this because Paul was preaching the good news about Jesus and the resurrection. Then they took him and brought him to a meeting of the Areopagus, where they said to him, "May we know what this new teaching is that you are presenting? You are bringing some strange ideas to our ears, and we would like to know what they mean." (All the Athenians and the foreigners who lived there spent their time doing nothing but talking about and listening to the latest ideas.) Paul then stood up in the meeting of the Areopagus and said: "People of Athens! I see that in every way you are very religious. For as I walked around and looked carefully at your objects of worship, I even found an altar with this inscription: to an unknown god. So you are ignorant of the very thing you worship—and this is what I am going to proclaim to you.

"The God who made the world and everything in it is the Lord of heaven and earth and does not live

in temples built by human hands. And he is not served by human hands, as if he needed anything. Rather, he himself gives everyone life and breath and everything else. From one man he made all the nations, that they should inhabit the whole earth; and he marked out their appointed times in history and the boundaries of their lands. God did this so that they would seek him and perhaps reach out for him and find him, though he is not far from any one of us. 'For in him we live and move and have our being.' As some of your own poets have said, 'We are his offspring.'

"Therefore since we are God's offspring, we should not think that the divine being is like gold or silver or stone—an image made by human design and skill. In the past God overlooked such ignorance, but now he commands all people everywhere to repent. For he has set a day when he will judge the world with justice by the man he has appointed. He has given proof of this to everyone by raising him from the dead."

When they heard about the resurrection of the dead, some of them sneered, but others said, "We want to hear you again on this subject." At that, Paul left the Council. Some of the people became followers of Paul and believed. Among them was Dionysius, a member of the Areopagus, also a woman named Damaris, and a number of others.

Acts 17:16-34

I often find that evangelistic street performance does especially well in cultures where religion is extremely upheld and traditional. This creates a vacuum for something down to earth, relatable, modern, simple, and new that is separate from religious legalism. The Suitcase Sideshow presents Jesus in all of those ways.

Many people see Christianity and legalistic religion as one and the same, due to what they grew up with, have been told by the media, or heard from other people. So one way to respond to that vacuum is to show them a different Christianity founded on Jesus and not self-righteousness. I do this sometimes by shocking them with something crazy in the beginning of our show that they would never expect. For example, my show *Blessed Are the Poor* begins with the Pharisee's prayer taken from Luke 18:9-14. The intro leads up to revealing a hero, but the hero is not the first to come out. The scene is dark with floating red eyes whispering spooky lies into the mind's eye of our viewers. Then there are flashing lights, fog, and funeral music, and out comes the religious, legalistic oppressor who prays a self-righteous, self-glorifying, prideful prayer that sounds as evil as it really should in the spiritual realm. This is unfortunately how many people see Christians, but when they later find out that Jesus is against this man's attitude and actions, they are surprised and fall more in love with our hero Jesus. It's a scary opening, and either people get scared and leave or they get pulled into it further.

One time the unthinkable happened at our show in Poland when we were performing during Woodstock for a tent full of over a hundred hardcore bikers. They tried booing us off the stage as we set up, but once this opening scene started, they instantly stopped booing, watched closely, and nobody left during the entire performance. The Christian bikers hosting the venue said they had never

seen that crowd so intrigued by a story so open about Jesus. One of the missionaries from Canada had been there for years and was completely shocked. The goal with this kind of approach is to show people the common ground they have with Jesus. He was against the same kind of religion that they are against. Jesus is the answer for the vacuum created by the oppressive religious culture they live in.

A couple times I have led an outreach at a parade in Minneapolis. The parade is rich with paganism, pride, and diversity, claiming to be open to any and every message in the name of "tolerance." I used to ride with the Scallywags Bike Club on tall bikes with back patches that said, "Jesus is Lord." We would ride crazy homemade bikes with the anarchists and have an incredible relationship with them. There was a vacuum being filled. All throughout the parade there is a lot of anger-fueled protest. But then all of a sudden, you see Christians having fun with the craziest and dirtiest punks in the city. You don't see judgment, you see kids laughing and people representing Jesus actually loving the people Jesus would have loved while riding funny bikes. One time we were riding right in front of a group of witches who we heard trying to force their kids to keep singing their songs. Instead they were laughing and chanting, "Roll! Roll! Roll!" with the rest of the crowd, urging our freakish circle bike[e] to do a double roll.

Another year at the parade, we presented a walking installation of a life-sized marionette display. Marionette people were walking around, but instead of being controlled by a puppeteer, their strings were attached to signs displaying different words that represented something

e A circle bike is a bike that has a curved bar that goes from the top of the front wheel, over the rider, to the top of the back wheel. The rider throws on the front brakes and circles over the front wheel in a summersault motion.

that controlled the marionette. All the words chosen were common-ground heart issues that most people in that part of Minneapolis don't want to be controlled by: Hate, TV, Gloom, Greed, Worry, Guilt, $$$, and Past. Again, in a place so centered on protesting the external, a vacuum for heartfelt issues emerges. We also had other people running around with scissors that had the name "Jesus" painted on them; and they were asking everyone, "Can I cut your strings?" They'd say things like, "Love is a better way than hate!" "You can be forgiven! Can I cut your strings?" "TV is full of lies!" "Don't worry about it, you are loved." "You are so special!" "You can be free from your past! Can I cut your strings?" Notice, we didn't pick things that people don't want to be set free from, like premarital sex or drugs. We find areas of common ground and build from there. We are resourceful in finding themes relating to interests and beliefs that people already have, because they've been created by the cultural vacuum. Then we present the gospel as the answer, because it is!

Show Then Tell

—

"For I am not ashamed of the gospel, because it is the power of God that brings salvation to everyone who believes: first to the Jew, then to the Gentile."

Romans 1:16

Show them Jesus before you tell them it's Jesus is an allegorical method of evangelism that was pioneered by others long before I started implementing it in my work, but finishing the allegory with who the story is describing is something not commonly practiced among artists. This is a shame, especially considering how effective it can be. I find that most Christian artists are either really open about Jesus in their art or very cryptic. The "Show Then Tell" approach is geared toward a post-Christian culture, specifically in the West, but I have seen it be very effective even in the Far East where the name Jesus has western and strong political connotations. The point is that people have a wrong idea of who Jesus is. They hear the name, and they just shut down and write it off. Feelings of political gain or traditional oppression flood their thoughts before they can even give his true character a chance. They assume they know what you are doing and what the show is all about based on their experiences. But as David Pierce (a friend and mentor of mine) writes in his book *Revolutionary*, "The Jesus they reject, you would likely reject also."[8] They need to encounter the real Jesus and see his true passion for humanity.

In the evangelistic rock opera performed by the band *No Longer Music*, they show the heart of God all throughout the show. It begins with people inside a red blob using abstract modern dance movements to portray creation and then shows the Creator breathing life into humanity. Then the story continues with a broken relationship, the cross, and the resurrection—all without mentioning the words "God" or "Jesus." They use words like "Life Force" instead. They show the cross and the resurrection all in very modern ways, and then in the end, tell everyone it's Jesus. People get caught off guard because they have been brought through an incredible story where they see this radical hero defending the brokenhearted, and they like him. But when they realize it's Jesus, they are conflicted and are confronted with mixed emotions while the Holy Spirit is working in their hearts, revealing the truth they have rejected under false pretenses. The effects are drastic, and people often receive Jesus into their lives. I believe as messengers of the Gospel, we should be more resourceful in how we show the Gospel in action, word, and story before we tell those positioned before us who it is they are seeing.

Two of my productions utilize the "Show Then Tell" method. In my show *Blessed Are the Poor*, we show how Jesus responds to the injustice we see every day in our modern world. It uses modern versions of old Bible stories to show Jesus in a contemporary way. But, in many of the current translations of the show, I don't use the name Jesus until the very end. Many people figure this guy is something unique, but they won't know exactly who he is until the end of the performance. I do another show called *The Sailor and the Boat*. It connects the prodigal son story to the cross and resurrection story using sea shanties, shadow puppetry, tap dance, and sailor metaphors. At the very end, the name

of the Sailor is revealed as Jesus. People see the whole heart of God before their cynicism kicks in.

One time we did a show at a cabaret in Minneapolis for an audience full of artists and hipsters. We were the last and final act, and a couple acts before us were blatantly anti-Christian, evangelizing a godless lifestyle. A big theme of the night was how Christianity is leaving, and how the people and belief are becoming more and more extinct. I made a special effort to talk to the bands before we went on, because I truly do relate to their pain. I had experienced much of the same thing. Then it was our turn, and we did our show. It was one of our best performances and certainly a memorable part of the night. With tears welling up, I felt the Holy Spirit put power behind the last words said on stage, which went something like this: "We've all gone through storm and wind. Just look around; our world is on fire. But there is hope, because there is a Sailor who is old and strong. He gave his life for us so we could all experience real, lasting freedom. He loves us, and his mighty name is JESUS." The owner of the cabaret told me that he loved our show, wants us back, and loved how we revealed the name of Jesus at the end because of all the bad associations that crowd attached to it. We knew God did something powerful that night that we may never fully understand.

Earn Their Trust

—

"If it is possible, as far as it depends on you,
live at peace with everyone."
Romans 12:18

There are a lot of Christians today who really frown on preachy evangelism. The very word "evangelism" reminds them of soapbox preachers proclaiming scary hellfire and brimstone messages on the street corners. Because of that, I think many have started avoiding any approach to outreach where the gospel is clearly proclaimed, and instead have embraced a singularly relational approach to sharing their faith. They resonate well with the catch phrase often attributed to Saint Francis of Assisi: "Preach the gospel at all times; when necessary, use words." This quote is often twisted to fit the feeling that you have to know someone for a long time before you can ever tell them about Jesus, and that hopefully one day it'll come up in an un-awkward way because of how nice of a person you are[f]. This is a little strange to me considering that Saint Francis was a radical street preacher who never actually said such a thing, and who certainly wouldn't have meant it the way people often interpret it—as an excuse not to

f A proper interpretation of the actual saying by St. Francis is, "Let all the brothers preach by their works" and would be directed at preachers under the Catholic Order.[10] It serves as a rule to live out your faith consistently, so that when you do preach the gospel, you have credibility. It reminds us that we can't be jerks who disregard the commands of Jesus ourselves who then go on to tell others what they should believe. From that perspective, the saying is certainly true. The problem arises when people twist it to accommodate their own comfort.

speak—since that so would have gone directly against his character and actions.[9] Besides that, Peter preached to thousands on the day of Pentecost (Acts 2), Jesus preached to large crowds about the Kingdom of God (Luke 6:17-49, 9:10-17, Matthew 5-7), and when Jesus sent out his disciples in Luke chapters 9 and 10, he told them to go places they had never been before and *proclaim* the Kingdom of God there, even though the people they met would not always receive them.

—

How, then, can they call on the one they have not believed in? And how can they believe in the one of whom they have not heard? And how can they hear without someone preaching to them?
Romans 10:14

Good news is spoken! Everyone has the right to hear the good news of Jesus Christ. Think about that dream job you just got, or that album you just recorded. It's good news! Are you going to tell anyone about it? Yes, of course. So why do we feel like we can't tell anyone about Jesus? Do we actually believe the message of Jesus is good news? Why do we feel we have to wait for them to see it in our lives first before we can say anything? Now don't get me wrong, relationships were a huge part of Christ's ministry. When the disciples were sent out, they were told to invest in a local home (Luke 10:5-9). Jesus established many relationships with people from all walks of life, but the point was never to have relationships just for the sake of being accepted, but to build trust, which would hopefully lead to faith in him.

In Luke 7 Jesus has an encounter with a woman with a presumed sexually promiscuous background. She trusted Jesus enough to stick her neck out in her personal den of lions, a house full of religious leaders, to wash his feet and thank him publicly for something powerful that was changing in her inner being. I believe trust is a primary gateway into the heart, and it can be established in a variety of ways. Friendship is one way, but it can also be found through art.

Jesus and his disciples earned people's trust through all sorts of approaches—miracles, words of knowledge, and spending time with them, to name a few. Peter earned the trust of people on the day of Pentecost by miraculously speaking their language. We can build trust miraculously as the Holy Spirit leads; and as artists, we can also earn people's trust by entertaining them, humoring them, being relational, speaking their love language, giving them an experience, and loving them through genuine kindness.

One of the big reasons I love using art to present the gospel, is that it builds that instant connection of trust for relating to people and a common ground for discussion. You can meet somebody for the very first time and within minutes have had a common experience through art. A painting, a song, a drama, or some kind of spoken word can all open up a conversation. Trust can be established very easily through a shared experience and the connection made between a performer and an audience. We like to form trust through our shows, so that people will listen and receive our message with respect and more of an open heart. There are a number of ways that you can build trust with somebody through art.

"But in your hearts revere Christ as Lord. Always be prepared to give an answer to everyone who asks you to give the reason for the hope that you have. But do this with gentleness and respect...."

1 Peter 3:15

1) We earn trust by sharing the truth gently and with kindness. Not all persecution is good. If you are persecuted for being a jerk, that's your own fault. A lot of evangelistic-type personalities just like to talk and need to be careful how they say things. The Bible says to share in kindness. Be sure that if you are persecuted for the gospel, it is because of the gospel, not because you offend a bunch of people with your cultural or political views.

"Don't have anything to do with foolish and stupid arguments, because you know they produce quarrels. And the Lord's servant must not be quarrelsome but must be kind to everyone, able to teach, not resentful. Opponents must be gently instructed, in the hope that God will grant them repentance leading them to knowledge of the truth…"
2 Timothy 2:23-25

2) We earn trust by serving people around us. When presenting our show, we like to serve people. We try to hand out food or drinks. We offer them music. We do a skill

share. We share our story, and we seek to serve the needs of those around us. No crowd is too small, and if nobody likes the show we want to understand why, and we hope to gain their trust by listening to them afterwards.

When we were on our European tour in 2007, we did a show in Bern, Switzerland, at a homeless shelter run by the Salvation Army. There were about five weathered men watching the show, and at the end most of them had left. Then it turned out that the last one was there not because he liked it, but only because he couldn't move very easily and had to watch it. We sat with him afterwards and asked him if he liked the show. He said, "Not really." We talked about why for hours. We talked so long that his catheter bag burst and he was sitting in his own urine. He was so desperate for fellowship that it was worth it to him to sit there and let his catheter bag burst, rather than stop to change it. After we were done talking, he invited us to come with him to another homeless shelter that was serving lunch. We did, and as we sat down, the owners made a point that we weren't homeless, so we weren't allowed to eat with him. He made a huge scene in front of the whole place saying, "These are my guests, and they will eat here. They will eat here, and I will sit here with them, and I will not eat or move until they are finished." I asked him, "Are you sure about this? We can go somewhere else." He said, "No, it's not my problem, it's their problem, and you are my friends, so you can eat. Now eat." We ate and then left to go back to the Salvation Army where our things were stored. As we were about to leave, he gave us two Swiss francs. It was all he had. At first I didn't want to take it. I thought, *We don't need it; he needs it more than we do*. But then I saw that he was like the widow who gave to God all she had, and that was the greatest gift God saw. To take the money would give him the gift of dignity, because even though he

is poor and hard up for money, he is still human enough to give to what he believes in and to be a part of God's work. We took his money, and gave him the gift of gratitude, acceptance, and friendship. We gained his trust by giving him a gift through our show, sitting with him, allowing him to host us, and many other things God used to reveal his love to him.

We also gain trust of the local church by serving and in some cases, giving a hand up, instead of a mere handout that costs them nothing. There are occasional exceptions you will discover with discernment led by the Holy Spirit, but in general, if the local church does not take ownership in the work by sacrificing alongside us and helping in evangelism, the work will not last. We serve in order to gain trust, and we serve the local church and their mission by offering our time, experience, skills, and resources to help build them up to the point where they won't need us anymore and are inspired and motivated to try new outreach methods on their own. We like to work with local humanitarian efforts going on where there are established relationships, because that way, when people come to Christ, the follow-up will be natural. We find that oftentimes, trust is built over a time of serving in humanitarian ways; but crossing the line about why Christians are serving in Jesus' name and inviting those they are serving into a relationship with Jesus is surprisingly hard for some people to do. We come as a service to fill that gap and make it easy for people to talk about Jesus and take the next step, because it's in the show. It's something we all just experienced together, kind of like the weather. Now it's a common ground we can talk about. Our work has been very successful in this way.

3) We earn trust by spending time with people. We perform our show for anyone and earn their trust by

sitting with them and getting to know them as much as we can. I visited a homeless community under a bridge and volunteered at a state-run homeless shelter for years in order to gain trust so that I could present the gospel and show them a God who loves them through my art.

4) We gain trust by letting go of our culture and becoming all things to all people (1 Corinthians 9:19-23), up to the point of morally compromising. One famous missionary who did this well was Hudson Taylor. He went to inland China and adopted their culture by dying his hair, wearing Chinese garments, and growing out a beard and ponytail. This activity was incredibly controversial to his traditional counterparts back in England, but without morally compromising, he was able to establish relationships and earn the trust of the locals in ways no other known missionary to China ever had before.[11]

For a long time, I looked a lot like an anarchist punk. It was my style, and I felt compelled to reach these kinds of people for Jesus because God had given me a love for them. But when I started traveling overseas, my style got in the way a little bit. People wanted to know why on earth I would ever wear clothes with holes in them. Why was I always in black and wearing combat boots that weren't polished? I couldn't change everything, because you simply can't please everyone, but I did come face-to-face with style as an idol and the fact that I didn't want to be a missionary for western post-modernism. I wanted to be a missionary for Jesus. So if that means going crazy and changing my facial hair and clothes to relate more at Mardi Gras, I do it! If that means dressing more conservatively in Romania, I do it. Some people have criticized me for not being true enough to myself—losing my style, losing my look, losing my street cred. Maybe I have. But maybe

we should all stop trying to be so true to ourselves and start being more true to Jesus. Maybe I had to become nothing in order for Jesus to make me into something. I'm not saying you have to be someone you're not in order to earn someone's trust, but the more you become like Jesus, the more everything else really won't matter as much as seeing this person in front of you discover hope through a relationship with Jesus. So, be resourceful in earning the trust of your audience and *proclaim* the truth in love with passion from the Holy Spirit.

Go to the People

Jesus went through all the towns and villages, teaching in their synagogues, proclaiming the good news of the kingdom and healing every disease and sickness.

Matthew 9:35

During the 1900's it was common for ministers to host "crusades" where people would invite their friends to church for a weeklong event. I can't say I'm a huge fan of the title "crusades" given its origins, but I saw these events firsthand with my parents, as mentioned in my book *Travelogues of a Family Sideshow*, and they were amazing. Church families would invite their neighbors to a family-friendly event, and virtually the whole town would show up. They would hear the gospel and be ushered into a relationship with God and the church at the same time and place. God moved so powerfully. Billy Graham and many other famous evangelists tried this method, and it was proven to be very successful. The Great Awakening and a strong Christian culture came from much of these kinds of "revival" meetings. It changed my life as a child to be a part of it. But times are changing. My Grandpa Ed, who did the same thing, once told me, "The work of an evangelist has changed. People's lives are so much busier, and families don't function the way they used to. Everyone joined the rat race. People used to go to church because there wasn't much else to do and not much on TV. But today the work of an evangelist is very different."

Our culture has changed a lot; it is increasingly skeptical of the church and is distancing itself from any association with church or religion. What worked a few decades ago isn't the model we should use forever. That's why we are in love with the mission, not the method.

Today, expecting church leadership to do everything needed to reach people for Jesus by hosting a weeklong revival meeting isn't usually a method that works. We can't just invite people to church and expect the church to do all the work in presenting the gospel. We are the ones they trust, and so we are the ones who need to step up if they are ever going to experience Jesus. Now, there are cases where "crusades" are effective and where Jesus still uses people and ministers to speak directly into people's lives who are visiting a church meeting for the first time. God works in many ways. But that doesn't discount the fact that Jesus went *to* the people, and so should we.

The very essence of Christ's birth in a common place amongst common people proves that Jesus desires to go to the people. He spoke the language of the people and used modern stories called parables to describe his Kingdom. He ate where people ate, lived life how they lived it, and died with them as well. Jesus never lived in a fancy building until the "Christian religion" put him there. He has always been going to where the people are so that they will understand him, trust him, and love him.

I think mainly we just need to get outside the Christian bubble. This bubble is great for kids, families, and young believers who are not ready to be exposed to the counter-evangelism of the world. But as the mature disciples of Christ that we should all be growing into, we should not be comfortable in our bubble, inward-focused, inward-influenced, and seeking the approval of

fellow Christians. We need to step out, without forsaking the regular gathering of believers (Hebrews 10:25). Go to the people and speak their language, and when we get tired, beat up, or weary, come back to the church to be encouraged, get perspective, and then go back. We need to allow this principle to infuse every facet of our art. Drop the Christian bible college lingo. Drop the fancy theological talk, and get in touch with reality.

Christians throughout history have a long track record of being innovators of art, music, painting, architecture, and design. One time I was honored to visit St. Thomas Church in Leipzig, Germany where Bach wrote and performed his music. The church was basically the Tin Pan Alley of its day in the 1700's. Hearing a restored organ playing Bach's work in its original acoustics was a highlight of my life. I do think that the modern church has been making extensive strides in trying something new to incorporate more art in the regular gathering of believers that we call church. But unfortunately, it has seemed to benefit the building and the bubble, rather than impact the secular culture around us. It hasn't seemed that church leadership has always led the charge in empowering its local artists to be evangelistic impacters who use their God-given abilities outside the church to influence our world in the name of Jesus. Plato had a love-hate relationship with artists, poets, and musicians. In *The Republic* he wrote, "Musical training is a more potent instrument than any other, because rhythm and harmony find their way into the secret places of the soul, on which they mightily fasten, imparting grace, and making the soul graceful of him who is rightly educated, or ungraceful of him who is ill-educated."[12] To summarize other ideas from *The Republic*[g], he believed that if you could

g For example, "...any musical innovation is full of danger to the whole state, and ought to be prohibited.... when modes of music change, the fundamental laws of the state always change with them (121)."

control the artist, you could control the people better than any government, because art speaks to the heart in a way that government cannot. How much more, then, should we as messengers of Jesus Christ create art that carries his message of hope to the hearts of a dying world? Find the pain that is really out there, let it break your heart, and make art about that. Get relevant and relatable and take your art to the people outside the church in the streets, venues, and galleries! The message should never change, but the vehicle should always be changing and being examined to see whether any particular method is still relevant and applicable. We are in love with the mission, not the method. In our marionette street performance, we use costumes, music, stories, symbols, pictures, and metaphors that people can identify with that will point them to Jesus. We don't choose to do puppets because we love puppets (okay, I do like theater, music, and how marionettes can be a little creepy at times), but we do this because we have seen it work.

People say that Christian art and Christian music all sounds and looks the same, that it is cheesy, and that it has a certain twang or style to it. A lot of it does, but then again, so does a lot of secular art when it comes from an inward-focused scene. For example, I use to be heavily involved in an underground punk rock theater that had a huge reputation in the city for being cutting edge and controversial, and it was. It was a very exciting place. But one day I realized that the theater wasn't very controversial or cutting edge anymore. In fact, it was formulaic and predictable. At any given variety show, you could expect to see a rough mix of nudity, fire breathing, circus acts, and pagan rituals, and to hear something about feminism, war, eastern religion, bikes, and beer. It felt cliché and inbred. It attracted the same crowd and preached the same message to the choir, with little interest in reaching out past their

comfortable scene, but with every interest in pointing fingers and condemning those outside their scene. I think some Christian art is the same way—by Christians for Christians—and if we are ever going to be truly cutting edge and reach people where they are at, we need to get outside our bubble, go to the people, and speak their language.

There is a "holier than thou" rhetoric I hear in some Christian circles that I think holds us back from reaching outside the four walls of the church. It breaks my heart, and I believe it breaks God's heart too. It's as if some Christians think, "People are gross for the things they say and do, and we should stay away from them. We should protest their activity and maybe even punish them for their sin. There is no way we would ever want to live in the sewer with 'those' people or go to the same places and do the same things that 'they' do. It's the sewer!" This way of thinking is so wrong! You will never have the heart of Christ, who took on sin in order to be rid of sin forever if you see people through the "holier than thou" filter. Jesus always separated the sin from the sinner. He saw people not for what they did, but as victims of the enemy who need to be set free from believing the lies of the world that lead them to do hurtful things. We are holy (Hebrews 10:10), but not because of what we don't do. No, we are holy because of what Christ already did for us through his blood on the cross! Nothing more, so that nobody can boast except in Christ Jesus.

"May I never boast except in the cross of our Lord Jesus Christ, through which the world has been crucified to me, and I to the world."

Galatians 6:14

It's because Christ has made us holy that we have the freedom to touch the untouchable, love the unlovable, and mourn with those who are hurting. People are not gross! The sewage they live in may be gross to God, but he is the only one to truly judge that. Paul gave up his own rights so that he could show Jews what it meant to be a Jew who followed Jesus, or Gentiles what it meant to be a Gentile who followed Jesus (1 Corinthians 9:19-22). This doesn't mean we go to the point of sinning and accepting the sewage; it means that in the neutrally grey areas where it is more loving to let go of our pet peeves and take on a bit of culture we don't like, we do that, rather than stay in our rut of what feels comfortable while those around us suffer without God's love in their lives. Besides, their sin might be their only way to numb their pain, or their sad attempt at salvation without the full knowledge and understanding of true salvation founded on the love of Christ.

Once we finally come to understand that we need to get out of our Christian bubble and be resourceful in how we go to the people and speak their language—not because we don't get along with Christians and not just to be cool—there will be a new set of temptations that follows. Big temptations that show us why we are called to daily put on the full armor of God. It will be a battle, and you have just entered the front lines! I can't even count the number

of friends and people I have seen who had good intentions for reaching lost people for Jesus, but got too close to the enemy's camp only to fall in. The following points are a handful of thoughts mixed with scripture that you should meditate on. I pray they will aid you in examining your own heart so that you can keep your eyes fixed on Jesus amidst the temptations of the sewage.

"Finally, be strong in the Lord and in his mighty power. Put on the full armor of God, so that you can take your stand against the devil's schemes. For our struggle is not against flesh and blood, but against the rulers, against the authorities, against the powers of this dark world and against the spiritual forces of evil in the heavenly realms. Therefore put on the full armor of God, so that when the day of evil comes, you may be able to stand your ground, and after you have done everything, to stand. Stand firm then, with the belt of truth buckled around your waist, with the breastplate of righteousness in place, and with your feet fitted with the readiness that comes from the gospel of peace. In addition to all this, take up the shield of faith, with which you can extinguish all the flaming arrows of the evil one. Take the helmet of salvation and the sword of the Spirit, which is the word of God."

Ephesians 6:10-17

1) If we are going to get out of our Christian bubble and go to where the people are, we need to never call the sewer home. You may find the style to be very attractive, the art to be engaging, and it may look like it's for a good cause, but it is not home. The moment you forget that is the moment you allow the world's ideals to take root in your heart. I hate it when my brothers and sisters get enticed by a scene, even for a good cause, call it home, and then move in only to fall away from God. Remember that your home is with the Lord, and your comrades in the faith are your eternal brothers and sisters, even if they don't always share every interest.

—

"If you belonged to the world, it would love you as its own. As it is, you do not belong to the world, but I have chosen you out of the world. That is why the world hates you."
John 15:19

2) When we reach into the sewer, don't go to the parts of the sewer where the waste comes out. Don't go to the gateway websites or the places in town that will cause you to stumble. Don't get tangled in civilian pursuits of the world. If there is an area you are not ready to reach because it's too tempting, find another area and don't go to the hardest places unless you are given that unique calling and can go with accountability.

"Do not conform to the pattern of this world, but be transformed by the renewing of your mind. Then you will be able to test and approve what God's will is—his good, pleasing and perfect will."

Romans 12:2

3) When we step out of our Christian bubble, Satan will always make the sewage look attractive when we get tired. A lot of people are tired. It's so much easier to just zone out and be filled with whatever is convenient when you're tired, instead of resting in the presence of God. Satan tempted Jesus when he was tired and hungry and alone in the desert. He will do the same to us.

"Come to me, all you who are weary and burdened, and I will give you rest."

Matthew 11:28

4) Lastly, when you are ready to step out of the bubble and go to the people, never forget to always dwell on Jesus, instead of on the sewage. Keep your eyes on Jesus. Again, this isn't about a list of dos and don'ts; this is about keeping your eyes on Jesus, knowing him, always refilling yourself with the Word, and fixing your attention on the cross and Christ's sacrifice for you. It's because of the cross that you don't have to let your heart get overwhelmed with condemnation. You might hear gossip in the sewer, but you don't have to dwell on it or let it affect how you see another

person. Many people are subjected to pornography frequently because society has decided sexy pictures and risqué selfies are normal, so it's everywhere. Men know they shouldn't be staring. And then they just look at it *more* because they think, "Oh, I've already seen a celebrity basically naked. I may as well just keep looking." No! That's a lie and a downward spiral. Turn away! It's not too late to turn away and not dwell on it. Take that thought captive (2 Corinthians 10:5). Yes, we live in a sewer. You're going to get dirty, but don't fill your heart with sewage (Romans 6:12)! Be smart and dwell on Jesus, not the sewage, and you will make an impact instead of being impacted.

"Finally, brothers and sisters, whatever is true, whatever is noble, whatever is right, whatever is pure, whatever is lovely, whatever is admirable—if anything is excellent or praiseworthy—think about such things."
Philippians 4:8

We go to the people and present our show in places where the gospel doesn't always go: street corners, punk clubs, homeless shelters, and wherever we can find a crowd who will listen. We take the show to small towns where their view of God may be very narrow and traditional, and we show them something new that will hopefully breathe fresh life into their hearts. We go to the people instead of expecting them to come to church. A lot of Christian bands say, "If you want to know more about God, then come talk to us." We do that too, but instead of waiting for them to come to us, we also go to them. After you have shared your art, go out to the people. Get to know them. We extend our

hand in appreciation for them watching our show. We say thank you as we walk into the crowd and shake hands with the audience and talk to people until we find those who are interested in the message.

—

"Therefore go and make disciples of all nations, baptizing them in the name of the Father and of the Son and of the Holy Spirit, and teaching them to obey everything I have commanded you. And surely I am with you always, to the very end of the age."

Matthew 28:19,20

In my show *Blessed Are the Poor*, we show three real life stories using real types of people from today. The stories and what they say comes straight from scripture, as well as from the people that I met and knew from work, my travels, and The Curbside Jesus Project[h]. The show also includes another unique element—spiritual voices that whisper lies everyone can relate to into the characters' heads. Jesus appears in each scene as a hero for our souls, and when he speaks truth, the evil lies are exposed. Each part takes you through brokenness, healing, and then celebration. The main themes in the 25-minute show are trust, security, success, freedom, hope, and forgiveness. These are things everyone relates to and is thinking about. This is just one example of taking the gospel to the people.

h The Curbside Jesus Project is a bicycle ministry I started many years ago to bring prayer, food, cold water, and resources to people flying signs and asking for money on the on/off ramps and sidewalks in Minneapolis.

All in all, going to the people as a street performer or not is probably one of the hardest hurdles for many Christians to get over, and I think it comes down to fear. The fear of the unknown, the fear of rejection, the fear of doing something untraditional, the fear of messing up or saying or doing something that is unintentionally offensive or even counterproductive to people coming to know Jesus. The truth is that none of that is our concern if we go in love.

—

"For the Spirit God gave us does not make us timid, but gives us power, love and self-discipline."
2 Timothy 1:7

In Revelation 21:8, we read that a lack of courage is worthy of the lake of fire. We need to be courageous because we know that the One who stands by us every time we speak the name of Jesus is the same One who said, "BE," and there was. He said to the wind and waves, "BE STILL," and they were. It's that same power that can live inside of us—the same power that raised Jesus from the dead! Love casts out all fear: fear of being imperfect, fear of looking like a fool, fear of saying the wrong thing, or fear being one of *those* Christians. You know, the kind everyone hates. We all want to be the *cool* Christian that everyone likes. Well, they hated Jesus. Not because he was rude or mean, but because he spoke the truth and drew a line in the sand. Dear Christian artist, they hated Jesus and crucified him. We are not above Jesus. Who are we trying to impress, them or God? Step out of the boat like Peter (Matthew 14:22-33), be obedient to the Holy Spirit, kill your art by overcoming your fear, and go to the people.

[8] Pierce, David, et al.. *Revolutionary: Ten Principles that Will Empower Christian Artists to Change the World*. Steiger International Press, 2013, p. 57.

[9] Assisi, St. Francis. *The Writings of St. Francis of Assisi*. Robinson tr. The Dolphin Press, 1905, pp. 40-41.

[10] Galli, Mark. *Francis of Assisi and His World*. InterVarsity Press, 2002, pp. 121-130.

[11] Collom, Fred. *The Dumb Gringo: How Not To Be One In Missions*. Xulon Press. 2004, pp. 31-43.

[12] Plato. *The Republic*. Jowett tr. Barnes & Noble Classics, 2004, pp. 95, 121.

He said to them, "Go into all the world and preach the gospel to all creation..."

Mark 16:15

TAKING ART TO THE STREET

APPLICATION

City streets have historically been loud and full of peddling ideas. During the early 19th century, the sounds of paperboys and soapbox preachers filled the air. Musicians would rent a barrel organ, music box, or organ grinder and take it to the city streets for the day and play for tips. The advent of cinema lead to the decline of theater and thousands of actors and circus performers took to the streets to try their show on a new transient audience.[13] Today you'll see techno brass bands, bucket drummers, live statue art, dancers, puppeteers, and musicians to name a few—peddling new ideas and adding culture to the city streets. These are great ways of getting outside the box to proclaim the greatest culture of God's love to a dying world.

The remainder of this book will focus on the practical side of being an evangelistic street performer from the perspective of The Suitcase Sideshow, Story Box, UniShow, and the Jesus Kitchen, which are all street outreach projects that have been very successful in their calling[i]. The following is a combined look at these

i I would like to recognize the contributions of Charles de Bueger of Story Box, Dustin Kelm of UniShow, and Molly Paulson of the Jesus Kitchen in this chapter. Story Box is a theatrical busking presentation of the gospel that uses theater, puppets, and music. UniShow is a unicycle presentation that uses unicycle stunts to tell stories and preach the gospel. The Jesus Kitchen is a street outreach that fed people on the sidewalks of Minneapolis and the Rainbow Gathering while creating a welcoming environment for conversations about Jesus.

approaches, with slightly more emphasis on The Suitcase Sideshow, and how they may aid what other people hope to do. This is what a typical street performance may look like if the philosophies of the previous chapters were put into practice when one kills their art by surrendering it back to Jesus.

Pre-Production

Before we can do any performance, the first priority is getting a heart for the place we are performing and developing the correct show. We value seeing the country, eating traditional food, and hearing about local politics and social dynamics. It's amazing what you will learn from other people's perspectives if you hold your own culture and politics with an open hand. We love talking to locals and seeing real life. Something I value a lot about a Suitcase Sideshow marionette tour is that it is slow. It allows time for investing in local relationships and truly getting a sense for where people are at so we can really feel God's broken heart for where we will perform. When we tour and perform shows, it's hard work. But we always remember to have fun, recharge, see cool things, and get to know the culture around us. This makes us more relatable and helps us understand more of where we are.

Next we need to develop the proper show, translating and recording the show into the language of the audience. Depending on the story, we will also need to translate it into the culture, remembering (as I wrote earlier) that we need to pick a show that fills the cultural vacuum of the location and reveals Jesus to the people in a way they will understand. Then we will work with translators to record the show into the language of where we are going. This can be done through the local church when we arrive or in an earlier trip. After the soundtrack has been recorded either on location or by our hosts ahead of time, we can edit the script and the dialogue to fit with the sound effects and music. Then after a few practices, we are ready to perform.

Finding a Location

Our performance locations can be almost anywhere depending on the style of our show. We have done our show on many street corners (check for necessary permits), and in homeless shelters, juvenile detention centers, brothels, parks, orphanages, theaters, and social service centers. Finding the right location is very important for the success of the show and can take some trial and error. There are a lot of (often unknown) variables involved. In general, you want a place with high foot traffic that is a public destination. What does this mean? A train station has high foot traffic, but it is not a place that people actually want to visit. They are all trying to get on trains, and most don't want to stop and listen to you for more than a couple of minutes. Shopping malls have high foot traffic and people go there to hang out, but they are not public places. They usually have an army of private security guards who will stop you within five minutes, unless you get permission. Seaside promenades and parks are destinations that people go to hang out at, and usually the security guards are more relaxed. However, unless you find the right place in the park and go at the right time of the day, you may not have that many people in your crowd. Walking streets can work well, as long as you don't block too much foot traffic or annoy the local shopkeepers with excess volume. We always aim our show away from businesses and ask their permission before we set up. Ambient noise can also be a factor. We don't want to compete against excess traffic noise, waterfalls, piped music from nearby restaurants, or other street performers.

Sometimes a city or culture will come to life after

dark, and sometimes before. That will likely dictate the best time to gather your biggest crowd. However, if we can help it, we prefer not to do street performances in the heat of the summer. Warm evenings beginning at sunset work very well; people are just out and about, and the darkness both lends atmosphere (with our stage lights attracting people like a moth to the flame) and also makes people in the crowd feel a bit more anonymous since they can't be seen or recognized as easily. This is more necessary in countries where accepting the gospel might have negative community and family ramifications. There are also fewer visual distractions at night, so it's easier to draw people's attention to the show. If we do perform during the day, we try to arrange it so that the crowd doesn't have the sun in their eyes while they are watching. At the end of the day, even the "worst" place in the world can be awesome if just one person who is really seeking the gospel comes along and engages with you.

We do not generally advertise our show to the public for a street performance; however, advertising in a private location like a homeless shelter, orphanage, school, or institution can help build anticipation. We love to work with churches and groups where they have already built trust and relationships with those they are socially reaching out to. That makes follow-up, depending on the response, way more natural. This way there can be more long-lasting results and guaranteed discipleship.

We need about thirty minutes to set up and thirty minutes to break down, depending on the location, which works out to about three hours from arrival to departure. We have our own battery-operated, portable lighting and sound system, so we can do our show just about anywhere. However, it is always a more impressive show when we can plug our lights in and use a larger sound system.

The bigger the sound, the bigger the show will seem, but make sure to check with the local authorities and business owners for the legal decibel allowance with and without a permit. With a good sound system, our show can hold the attention of about 150 people, but with our portable sound system, maybe 50. For us, no crowd is too small. Most of our shows are geared towards mature audiences, ages 10+. We will not turn down an opportunity to perform for young kids due to the fact that they enjoy the visual stimulation and really do understand more than we give them credit. However, due to the heavy, real-life content in our shows, most of the message goes right over the heads of young kids. So we prefer to make it as clear as possible that this is a marionette theatre for mature audiences. That oftentimes shocks church workers who think puppets are just for kids. This is a hurdle we are constantly working to get over until the show begins, and then they get it.

When we look for a location, we always ask the permission of those who are nearby drinking their coffee or visiting with their friends. Even though we usually have every right to set up and present our show, they were there first, and we are courteous to ask permission. Of course they are surprised we would even ask, and they say, "Yes, of course, go ahead." But then they ask what our show is all about, to which we respond, "It's a story about hope" (see "Show Then Tell" section). Often, they will then stick around and watch the show, and since you made a pre-show connection, you can easily follow up with them after the show and talk about what they just saw. If you feel uncomfortable meeting and introducing yourself to strangers, this sort of outreach may be challenging at first, but as you go out, just remember to ask God for his broken heart and he will help you see the right person you are supposed to talk to. Eventually saying the right or wrong

thing won't matter anymore. It's more about being available to make a connection and allowing the Holy Spirit to open the doors. Be outgoing and try to get in amongst the people in the crowd before, during, and after the performance.

Drawing a Crowd

Drawing a crowd for a street performance is an art of its own that can take time to master. There are four main styles of busking that draw four different styles of crowds. I refer to them as walk-by acts, traffic performers, café busking, and circle shows. The most effective styles of evangelistic street performing are circle shows and café busking, because they allow you to perform for an extended amount of time before a captivated audience who learns to trust you with their listening ear.

Walk-by acts tend to be easier to find a location for, but they are not as suited to giving a message, unless the act is singular in its statement and easy to grasp. As the name suggests, with this type of performance, people will not stick around very long to really hear you out and see your show. The show is seen as mostly background art to enhance the mood of the established environment. Something you can try for getting a message across to a transient audience, though, is having some kind of sign or a QR code that people can read or scan on their smart devices to discover more information about your act. Some buskers use this as an easy way to help people leave tips via digital payment method. The types of performance art that work best with evangelistic walk-by acts are music and live statues. Live statue art is not something I have seen too often used evangelistically. Typically, someone paints themselves gold, and stands or sits motionless on a pedestal. They might be dressed like a famous figure or do some kind of slow robot dance if you put money in their hat. One example of evangelistic live statue busking that I have seen is for someone to dress up like Jesus on the cross. If you wanted to expand on this, you could paint the

entire spectacle in gold and have a bucket of soapy water with a sponge next to a sign that reads, "More than a piece of jewelry. This is true love. Receive this gift by washing the gold vanity from the savior of humanity." Then see if people stop, read the sign, and respond to the statement by washing the paint from the real life statue.

Traffic performers entertain for a captivated audience held hostage by traffic laws and public transportation. The main two types are *subway train buskers* and *stoplight performers*. Subway train buskers typically perform a quick show by playing music or pole dancing while people sit, trapped inside a subway train in-between stops. This form of busking is mostly illegal, but a lot of people feel it turns a boring train ride into a community-building event. Stoplight performers entertain at traffic intersections for an audience sitting in cars waiting at stoplights. They have a quick, 20-second show, typically juggling, acrobatics, magic tricks, or dancing, and then they split up between the cars to collect money. I saw this once in Brazil with jugglers who climbed three high on top of each other's shoulders, juggled pins, and then jumped down to all collect gratuity for their entertainment during the otherwise boring stoplight wait. I have heard of some evangelistic subway train buskers who should exercise extreme discernment given the nature that their crowd is trapped and unable to leave if they don't want to hear about Jesus. Someday I would love to see an evangelistic stoplight performer.

Café busking is mostly done in pubs, restaurants, and cafés for tips. I think this style of busking became romanticized in the 1970s when big names like Billy Joel and Bob Dylan put piano bars and street corners on the rock n' roll map of venues with hit songs like "Piano Man" and "Like a Rolling Stone."[14] As an evangelistic café busker performer, I have had the privilege of taking my act to

many other unconventional venues as well, where people have hit rock bottom and are open to Christ. These shows are very amazing and the Holy Spirit can move powerfully. When these places are also home to a humanitarian effort with built in follow up, the results are long lasting. I've seen single moms in safe housing find Jesus, abused mentally handicapped kids find their voice in government housing, whole orphanages come to Christ, and gang members publicly proclaim Jesus at a prison camp. God is so amazing!

Circle shows are a type of act, mainly using theater and acrobatics, which captivate an audience for a precise amount of time. The name comes from dragging a rope in the form of a circle to create a perimeter for the audience to stand behind, while the entertainer stands in the middle to perform. They have the ability to grab some of the largest crowds, which makes finding a quality location more challenging, as they have to be proactive about not disrupting traffic and shops.

One thing to remember with evangelistic circle shows is that a crowd draws a crowd, so when the first performers start to do their thing, some helpers should sit down, and others can stand and watch so that passersby will want to stop, sit, and see what's going on. As more people stop to watch, then the helpers need to pull back to leave space for them. A shocking mix of fire, costumes, and dance is especially good for drawing a crowd, but if you have other "tricks" you can pull off—like illusions, martial arts, unicycling, juggling, or live painting—then by all means use them to draw and engage a crowd. In our experience, the performances that are most effective at drawing a crowd are things that are high-energy and rare or not seen before. Two guys playing the acoustic guitar is not that interesting compared to seven people all doing

a drama with lots of movement or a singing musical saw. Usually, the more people performing, the better, since it looks like more of an event.

If you can establish a connection with someone in the crowd before or during the show, there is a much higher chance that they will stick around through the whole performance and talk to you afterwards. We do that by sometimes offering refreshments or popcorn. It's a lot of fun, nobody expects it, and it makes people very intrigued about the experience they can have watching a spontaneous fringe puppet theater perform in the street. We also help people feel relaxed and comfortable by playing some accordion music.

Crowd management is very important in street theater and is a job for the announcer. If the crowd gets too big and starts blocking the road, you may have problems from the authorities. Sometimes it is necessary to have your friends or people on your team actively ask people to move closer to the performers so that you don't get in trouble with the police. The announcer needs to be mindful of this and offer folks a closer place to stand or sit. Getting people to sit for a street performance is incredibly hard but rewarding. People are less likely to leave if they have committed to sitting down. So have your friends break the ice by sitting down in front so that others feel comfortable to do so as well. Then as you announce the show, offer up that option as "the best seats in the house." People will laugh and often take you up on your offer, unless it's cultural not to sit on the ground like we have seen in some countries. Once we have a crowd, we will begin the show. If we just can't get a crowd, we will start the show, and usually a crowd will form.

The Performance

As the announcer, my job is to connect with the audience and make them feel comfortable and at ease. I usually make it a point to first tell people that the performance is a gift, and that we do not want their money. That puts them at ease and allows them to enjoy the show without feeling any pressure to give us money. I also tell them how long the show is so they have a way to gauge how long they can stay. I also tell them it has some funny, scary, and sad parts, because it is a story about life. That way the parents are ready for anything strange that might happen, and people know it isn't going to just be a show for kids. Older kids and adults usually like this and chuckle a little as they understand that it's a show for them as well. I do my best as an announcer to build bridges by being genuine, light hearted, serving people's needs, and always thanking the local authorities for their support and permission. This will give you more credibility as well. Crack jokes, entertain, improvise, and serve your audience by giving them a real gift and a moment of sanctuary. I want them to feel like they are getting to see a special treat from a faraway land.

We also make sure to wear some kind of performance-appropriate costume. If the style of your show is old world, then maybe lots of tassels, fringe, a vest, cool hats, and accessories. If it's modern theater, black and minimal, bold colors will work. If it's a circus show, let your imagination be your guide. Without a costume, you might be taken less seriously or even seen as beggar, but with a costume you will be seen as a performer and probably treated as such as well. Some organizations create performer unity by wearing t-shirts with a logo on them. That can work,

but to me costumes say artist, whereas t-shirts with a logo say corporately mass-produced. In all of it, just know your audience.

Once we begin doing the show, we expect our hosts to watch the show and the crowd. They provide an example of how to be a good audience member. They should clap, cheer, and put their cell phones on silent. Some should sit close to the stage so others feel comfortable doing so as well, and others can stand in the back so they can talk to those who might have had enough and don't want to hear any more. As those people step away, that's the time to talk to them about the show and what has moved them off to the side, especially if someone on your team invited them or had a chance to introduce themselves beforehand through a gift or invitation. Some hosts like to hand out follow-up information such as surveys, pamphlets, or tracts at the show. This is a great idea, especially for helping you get a better connection to those who are genuinely seeking, but this typically works best when our hosts wait and hand these out after the show is over or as someone leaves. Implement the concept "Show Then Tell." Also, many people we work with like to take video and pictures during the show, which may be fine; but in private places that are more spiritually intense, we prefer that pictures and video be subtle.

The Aftermath

After the show is over, most of the time I will give a quick recap of the story and some closing remarks. Hopefully there will be a big response and people will come to Jesus, but it could also end in multiple other ways depending on the crowd and how the story moved them. We have seen a range of responses, from being angry and rioting, fighting each other, and throwing rocks, to walking away in tears, asking questions, needing a hug, loving the show, needing to just stand, stare, and think, or wanting to receive Jesus right then. When there is a big public response or show of hands for Jesus they may or may not all be authentic decisions, but they are all steps in the right direction. Never underestimate what God can do through someone letting go of his or her pride in a simple lifting of hands or taking a stand in saying yes to Jesus. It's in that moment of publicly acting upon a decision that faith goes from being merely intellectual to also physical. It's also in that moment that you will feel the spiritual battle going on possibly like you have never felt it before. It's a real rush!

As messengers of Jesus Christ, it's important when proclaiming the gospel, to keep the message very simple, relatable, and easy to understand with a clear way to respond. Then trust that people can make a decision to follow Christ based on their brokenness and willingness to receive God's love. If you are anything like me (an over-thinker who likes to complicate everything), you will find that it will be your greatest challenge to keep the gospel simple and easy to understand. That is an art worth mastering. A lot of us artists have a tendency to overthink things and a need to explain everything before asking people to take that

first step to follow Jesus, especially in an altar call. Nobody ever has it all figured out. That's why it's faith and takes the form of a back-and-forth relationship that grows and develops with God. Paul said in 2 Corinthians 6:2, "Today is the day of salvation," defining a certain moment that someone does make a decision to follow Christ, whether they have it all worked out or not. They can take that first step of faith and go from there.

After we have engaged with people's initial response to the show, we may also blow up some balloons for the kids, show people the marionettes, take some family portraits, or teach people how to play the singing musical saw to continue a relationship and a conversation. Someone on the team may need to make sure that the instruments and other gear is kept safe, but the rest of the team should do as much as possible to engage the crowd in conversation. Don't go and talk straightaway with your fellow performers to discuss how the program went; you'll be able to do that soon enough once most of the people have dispersed and there are only a few longer conversations happening. Don't start breaking down if a message is still being preached either. Remain engaged and in character. If you are nervous about chatting to total strangers by yourself, you are not alone! Take someone else from the team with you and talk in pairs. When everything is over and people have parted ways, then you may begin to break down the stage and head to the next location or go somewhere to debrief. Even if you didn't have any great conversations with someone, most likely someone else did, and that can be encouraging for all of us. It's good to pray for these people together and always debrief together to encourage one another.

One final thought on proclaiming the gospel is to be warned of the inner aftermath of that. In my experience I have never felt so low as after I have publicly proclaimed

the truth of the gospel. The spiritual attack that wages in your head will come on incredibly strong, and the lies will scream at you like you are the worst person alive. They will say things like "You're a joke. You're going to lose all your friends. Everybody hates you now. Nobody listened. You're a fool. The others on your team feel embarrassed by you. You just turned a lot of people away from Christ." There will be other lies depending on the show and person, and it will be intense. Expect it. When I first got started, it was the hardest thing to go through. I couldn't sleep and I didn't feel like eating. Later I learned how to put community and activities in place afterwards so I wasn't alone with my thoughts. Now, the attacks aren't so intense usually, and when they come, I take it as affirmation that what I just did must have been significant, otherwise the enemy wouldn't be wasting so much time on discouraging me from doing it again. This is a test I see most artists fail. They proclaim the gospel for the first time, and moments later I watch on their face as the spiritual battle moves into their head, and they never do it again. Press through and God will reward your commitment to his calling even more.

The Conversation

The moment after a creative performance that just unleashed the concepts of the hope, love, and forgiveness found in the gospel, is a very special window for having a conversation that doesn't commonly surface in everyday life. It's especially easy after this kind of performance, because it is an experience that everyone in the audience has just gone through together. So the show provides the common ground for natural conversation that will usher in real, deep discussion without being awkward, inappropriate, or pushy at all. This window is severely limited, however, so you want to make the most of it before starting another performance with another crowd or going to debrief over ice cream.

Turn the conversation to spiritual things sooner rather than later. Some folks are naturally good at this; others have to work at it. Asking honest questions about an aspect of the performance that had some kind of spiritual content is the easiest approach. Then listen without interrupting and give the person a chance to really speak. If you hear them out, they are more likely to hear you out. If they completely disagree with the show and the gospel, share your own personal story of how you met Jesus. That is something nobody can dispute, because it is your story.

Some good questions to start a conversation can be:

What did you think of what the announcer said?

What do you think about the way the drama/speaker/story described God?

What did you think about the show?

Did you relate to a specific character?

Did this show make you feel that God actually loves you?

Do you need prayer for anything?

"What" and "how" questions are usually better than yes-no questions because they require more thought and prompt more in-depth answers that can lead to a real discussion. If people don't respond with something that shows they are interested in talking about God, politely move on to someone else who does look interested in talking about God.

Beware of those who just want to argue or waste your time. Satan may send someone who is a time waster so that those who are really interested in talking about Jesus can't find someone to talk to. This happens all the time, and you feel bad because you don't want to be mean and break off the conversation. You shouldn't be mean, of course, but you also have to keep your priorities straight and be responsible with this special window of time you have to talk about the content everyone just encountered together. When the Holy Spirit reveals those who are interested, prioritize them. Be discerning of those who just want to suck your time away. I have many friends who are very intellectual and even seem to enjoy the feeling of superiority they get when they defeat others with their intellect. The problem with that is that you're rarely going to help someone find God's love by winning an argument over them. The only way they will really find Jesus is if they enter into a place of humility and admit that, when put to the test, all their knowledge doesn't compare to the power of God's redemption. Sure, answer their questions as best you can, find answers, learn their hurts, and hear them out. Give a good defense for following Jesus, but just be sure to prioritize those who are genuinely seeking. In season and out of season, always be ready to defend your faith (2 Timothy 4:2). Be bold!

At the conclusion of a conversation, offer to pray for the person and try to get their contact details so that the

local church can follow up and stay in touch with them. If you feel like they are really clicking with your conversation, ask them, "What is keeping you from giving your life to Jesus right now?" If they can answer that question, then ask them if they would like to pray with you to ask Jesus into their lives right then. I like to always remind them that prayer is just a conversation with God, not repeated Christian words in church that don't mean anything. If they talk to God, and really mean it in their heart, he will hear their prayers. I then offer to pray with them to ask Jesus into their heart. Jesus called us to repent, believe, change, and join his mission. So a simple prayer that includes those points might sound something like this:

———

"Jesus, thank you that you love me. Thank you that you died for me and defeated death. (Believe) Forgive me for the bad things that I have done. (Repent) Come into my life and change me. (Change) I want to follow you for the rest of my life. (Join the Mission)"

The exact wording can be flexible as long as the main points remain the same. I like to always pray for them after that and commend them for their courage in the radical decision they just made. I also make sure that when I pray for them or lead them in prayer, I don't use Christian lingo that they won't understand. I use normal words— "bad things done" instead of "sin," "change me" instead of "sanctify me." Again, we always speak the language of the people. I also like to remind them that this world hates us and tries to destroy us with lies ("you're not beautiful enough," "God can't love you," "you can't be forgiven," etc.) and will discourage them from what they just did. So we need each other. I explain that that's what the church is,

not a building, and that we need to be together, so let's get connected. Get their contact info at that point, or introduce them to someone local so that discipleship can continue. We do not want this to be a flash in the pan experience. We care about making disciples, and this method of using art as evangelism is a mere stepping-stone to making true disciples who will hopefully go on to make more disciples.

Conclusion

In all of this, you have to ask yourself two questions: What is your goal, and are you meeting it? Is your goal only to make exceptional art, or is it to help people discover the power of God's redeeming love as well? If your art is a dream profession to provide for your family, that's admirable. If it's a hobby, that's fine too. But no matter what we have or what we do, the best way we can make the most of it is always to surrender it back to Jesus. Kill it, and let it be reborn into a new life that will produce eternal, tangible fruit for building God's Kingdom here on earth. Even plumbers and accountants who have experienced the love of God seek opportunities to share it when given a platform, and their work doesn't obviously shape culture nearly as much as the work of an artist. If you're not meeting your goal, it's time to go back to the drawing board.

Won't you join us as Christ "Creatives" and surrender your skills, ideas, dreams, passions, and comfort to the One who gave it all to you in the first place so that it can be given a new life and bear much fruit? We all have a part to play in this great adventure. Start with what you have. If it's not a big show, maybe it's a puppet, giant bubbles, a canvas, three beanbags, or an early 19th century styled one-man band. Start there, think outside the box, be bold for God, and let him direct the show. A ship can't be steered if it hasn't set sail. Kill your art.

[13] Cohen, David and Ben Greenwood. *The Buskers: A History of Street Entertainment*. David and Charles, 1981, pp. 159-160.

[14] Cohen, David and Ben Greenwood. *The Buskers: A History of Street Entertainment*. David and Charles, 1981, p. 185.

Photos

The painted lid of the original Suitcase Sideshow

Philip & Sari performing

School performance, Chile

The Rock Gallery, Brazil

Street performance, Turkey

Mardi Gras, New Orleans

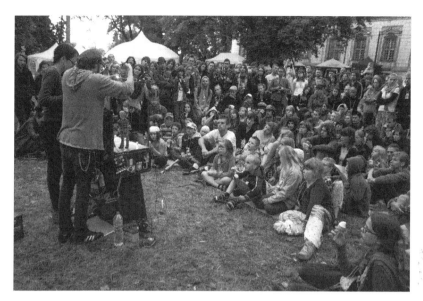

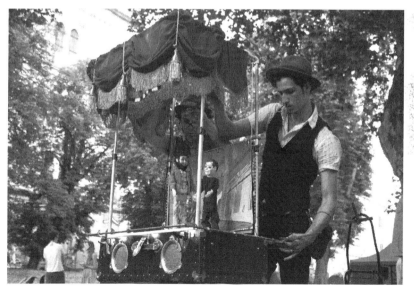

Slot Art Festival, Poland

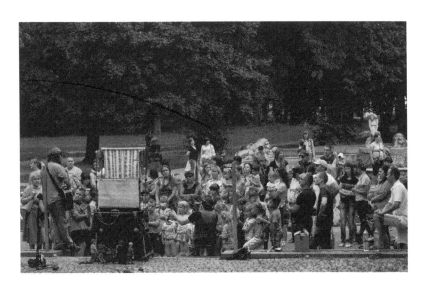

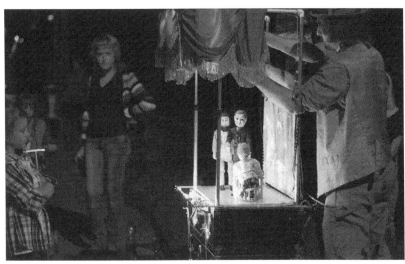

Street Performance, Ukraine

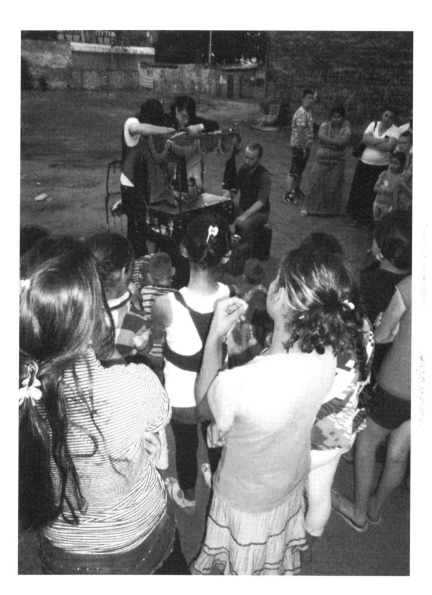

Street Performance in a Roma Neighborhood, Poland

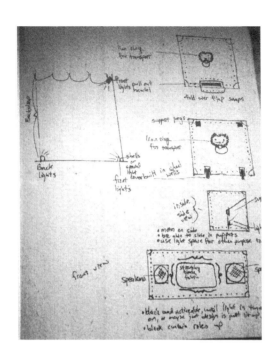

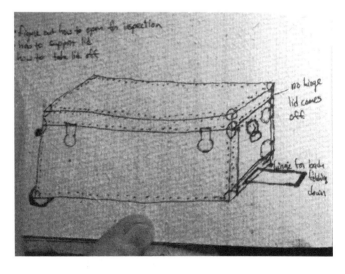

Early sketches for the Suitcase Sideshow

Lord of the Fingers & Philip Shorey, Italy

The *Madness of Folly*, Scally-waggin

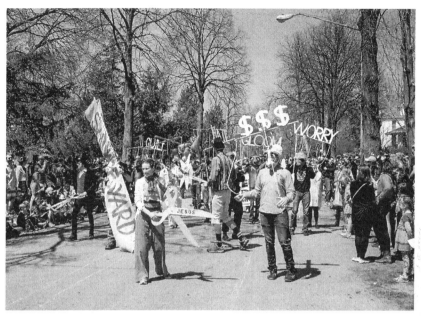

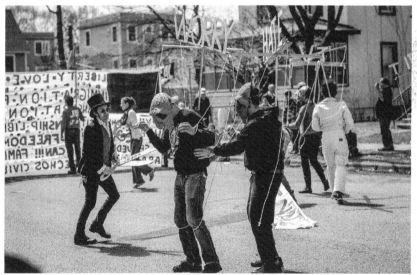

May Day Parade

The Sailor and the Boat

Blessed are the Poor

Biblical References

Kill Your Art
Matthew 16:24
Ezekiel 4-5
John 12:24
Mark 8:36

Heart over Art
1 Samuel 16:7b
Exodus 36:1,5 39:1,5,7,26,31,43
1 Corinthians 1:26-31
Colossians 3:23
Ephesians 3:20-21a

Art as an Idol
Romans 1:25
Genesis 22
Jeremiah 2:12-13

Dirty Laundry Art
Mark 9:42
Ephesians 4:29
1 Corinthians 6:1-6
James 3:1
Philippians 2:3-4

Art and the Struggle
James 1:2-4
Matthew 8:28-34
Ephesians 6:12

The Art of Resourcefulness
Matthew 10:16
Luke 4:16-30
Luke 8:9-10
2 Peter 3:9

Shock Treatment
Luke 5:24-26

The Cultural Vacuum
1 Corinthians 9:19-23
Matthew 4:17
Mark 1:15
John 3:16
John 8:24
Matthew 18:3
John 14:15
Matthew 28:16-20
Luke 24:44-53
Mark 1:17

John 3:3
2 Corinthians 5:17
Romans 10:9
John 14:6
Acts 17:16-34
Luke 18:9-14

Show Then Tell
Romans 1:16

Earn Their Trust
Romans 12:18
Acts 2
Luke 6:17-49
Luke 9:10-17
Matthew 5-7
Matthew 14:13-21
Luke 9
Luke 11
Romans 12:18
Romans 10:14
Luke 10:5-9
Luke 7
1 Peter 3:15
2 Timothy 2:23-25
1 Corinthians 9:19-23

Go to the People
Matthew 9:35
Hebrews 10:25
Hebrews 10:10
Galatians 6:14
1 Corinthians 9:19-22
Ephesians 6:10-17
John 15:19
Romans 12:2
Matthew 11:28
2 Corinthians 10:5
Romans 6:12
Philippians 4:8
Matthew 28:19,20
2 Timothy 1:7
Revelation 21:8
Matthew 14:22-33

Taking Art to the Street
Mark 16:15
2 Corinthians 6:2
2 Timothy 4:2

Works Cited

Assisi, St. Francis. *The Writings of St. Francis of Assisi*. Robinson tr. The Dolphin Press, 1905.

Bonhoeffer, Dietrich. *The Cost of Discipleship.* Macmillan Publishing, 1963.

Cher. "*Gypsies, Tramps, and Thieves.*" Gypsies, Tramps, and Thieves, MCA Records, 1971.

Choung, James. *True Story: A Christianity Worth Believing In*. InterVarsity Press, 2008.

Cohen, David and Ben Greenwood. *The Buskers: A History of Street Entertainment*. David and Charles, 1981.

Collier, John. *Punch and Judy: A Short History with Original Dialogue*. Dover Press, 2006.

Collom, Fred. T*he Dumb Gringo: How Not To Be One In Missions*. Xulon Press, 2004.

Fonseca, Isabel. *Burry me Standing: The Gypsies and Their Journey.* Vintage Departments, 1995.

Galli, Mark. *Francis of Assisi and His World.* InterVarsity Press, 2002.

"*History of Puppetry in Britain.*" October 2016, www.vam.ac.uk/content/articles/h/history-of-puppetry-in-britain.

Pierce, David, et al.. *Revolutionary: Ten Principles that Will Empower Christian Artists to Change the World*. Steiger International Press, 2013.

Plato. *The Republic*. Jowett tr. Barnes & Noble Classics, 2004.

"*Roy Adzak Quotes.*" Aug. 2016, www.art-quotes.com/auth_search.php?authid=576#.V64ptnAq68k.

Schaeffer, Francis. *Art and the Bible*. InterVarsity Press, 1973.

Contact

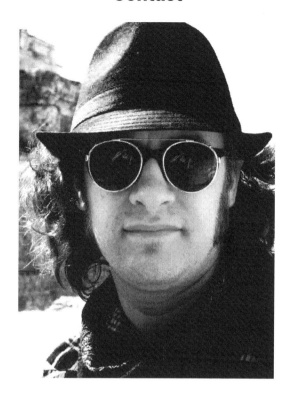

Philip Shorey

Author, Founder and Director of the Suitcase Sideshow.

The Suitcase Sideshow

www.suitcasesideshow.org
suitcase.sideshow@steiger.org

Minneapolis, Minnesota, USA

XXII CONTACT

Partner

1) One of the visions for this book is that it will inspire a *Kill Your Art* movement of more evangelistic street performers. If you want to play a part in that or if you have thoughts, questions, or want to know more about booking the Suitcase Sideshow or Philip Shorey, please contact us.

2) As you can imagine, being a missionary as an evangelistic street performer is no easy task. We are backed by Steiger International, and sent out by supporters who believe in what we do and want to be a part of it as well. That way we can focus on the mission and not receive tips during our performances. If after reading this book you see the value in our ministry, prayerfully consider a monthly donation to this kingdom building work.

www.suitcasesideshow.org
suitcase.sideshow@steiger.org

65529932R00082

Made in the USA
Lexington, KY
15 July 2017